ADULT COLORING BOOK

BE INSPIRED

Skyhorse Publishing

Copyright © 2015, 2020 by Skyhorse Publishing
Artwork copyright © 2015 by Shutterstock/Bariskina (Introduction images)
Shutterstock/Benjavisa Ruangvaree (Image 1)
Shutterstock/An Vino (Images 2, 4, 7, 11, 23, 24)
Shutterstock/Elena Medvedeva (Images 3, 19)
Shutterstock/IrinaKrivoruchko (Image 5, 6, 8, 33)
Shutterstock/9comeback (Image 9)
Shutterstock/Snezh (Image 10)
Shutterstock/Polly Bel (Image 12)
Shutterstock/eva_mask (Image 13)
Shutterstock/ImHope (Image 14, 18)
Shutterstock/oksanka007 (Image 15, 16, 20, 25, 27)
Shutterstock/AstarteJulia (Image 17)
Shutterstock/Roman Poljak (Image 21, 31)
Shutterstock/Art-and-Fashion (Image 22)
Shutterstock/Cerama_ama (Image 26)
Shutterstock/Bim doodle (Image 28, 34)
Shutterstock/HelenaKrivoruchko (Image 29, 30)
Shutterstock/simpleBE (Image 32)
Shutterstock/mashabr (Image 35)
Shutterstock/L. Kramer (Image 36)
Shutterstock/Lexver (Image 37)

Skyhorse Publishing books may be purchased in bulk at special discounts for sales promotion, corporate gifts, fund-raising, or educational purposes. Special editions can also be created to specifications. For details, contact the Special Sales Department, Skyhorse Publishing, 307 West 36th Street, 11th Floor, New York, NY 10018 or info@skyhorsepublishing.com.

Skyhorse® and Skyhorse Publishing® are registered trademarks of Skyhorse Publishing, Inc.®, a Delaware corporation.

Visit our website at www.skyhorsepublishing.com.

10 9 8 7 6 5 4 3 2 1

Library of Congress Cataloging-in-Publication Data is available on file.

Cover design by Brian Peterson
Cover artwork credit: iStock/katflare
Text by Chamois S. Holschuh

Print ISBN: 978-1-5107-1118-1

Printed in the United States of America

INTRODUCTION

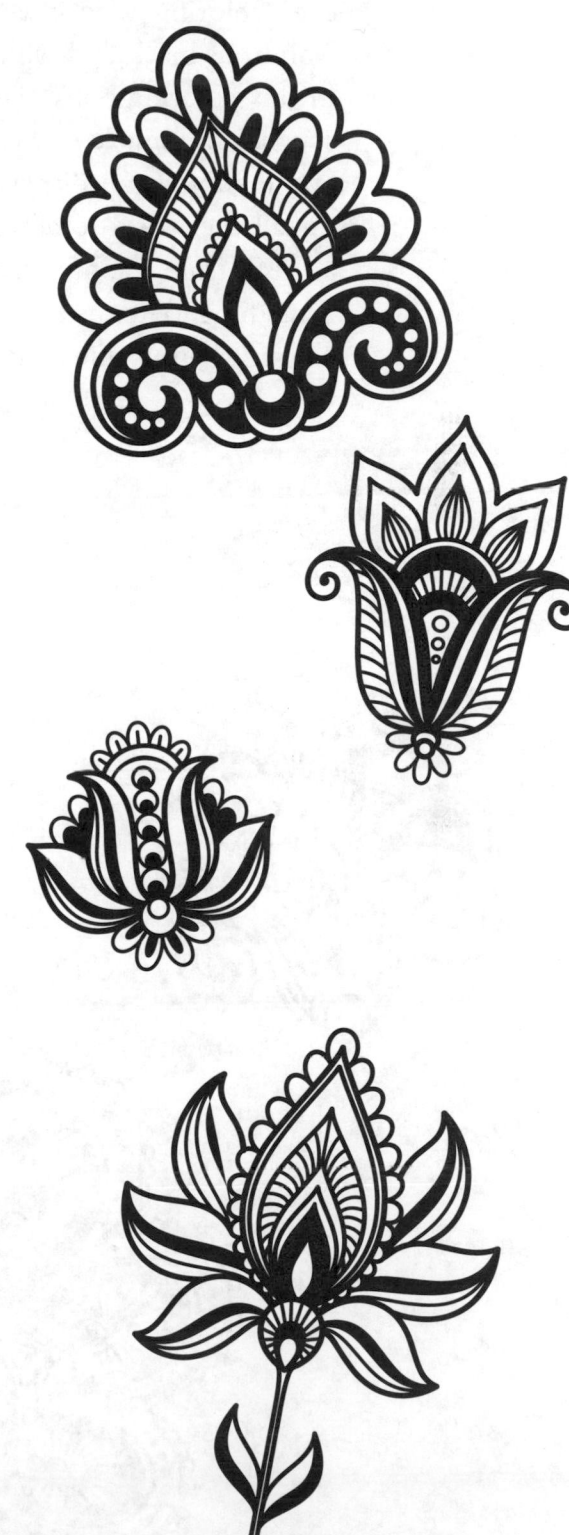

Get ready to be inspired! Coloring is one of the easiest artistic activities to get your creativity flowing. When we were children, we spent hours with our coloring books, inventing worlds of bold reds, wild greens, magical blues, and golden yellows. If our imaginative minds could conceive it, our fanciful eyes couldn't wait to see it.

Coloring enables us to explore our emotions in a proactive manner. Certain colors are often associated with feelings; for example, many people associate yellow with happiness and energy whereas lavender and soft blue are calming. Our cultural backgrounds often affect which emotions we assign to particular colors. For example, Americans may associate white with weddings and purity while black is representative of death and sadness. In India, however, wedding saris are often red while funeral parties dress in white. Various cultural factors and beliefs contribute to these hued preferences, demonstrating that humanity is a diverse palette. The color combinations you choose can be a way to showcase your background; use your culture to inspire your creations. Alternatively, mixing and matching can be a way to break convention. Unusual color combinations are fun to create and intriguing to look at when the fin-

ished product is displayed. Whatever you choose to design, this coloring book is full of opportunities!

It's time to revive that sense of wonder and dig out those colored pencils, crayons, markers, or whatever coloring utensil you prefer. Thirty-seven wondrous black-and-white designs are presented in this coloring book. The pages are perforated so you can remove them before or after coloring, and then you can display your finished artwork for all the world to admire. Whether you need a break from the humdrum of your workday or something to jumpstart your next art project, this coloring book is sure to stimulate your imagination.

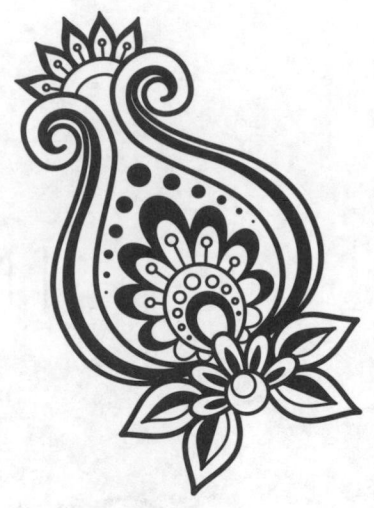

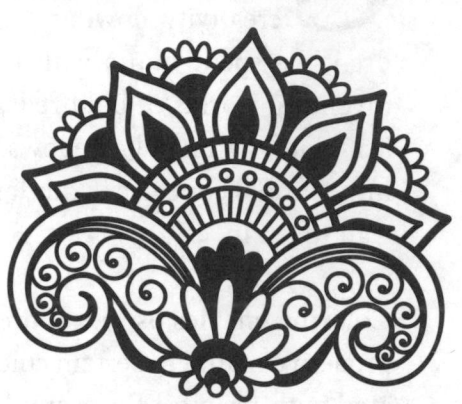

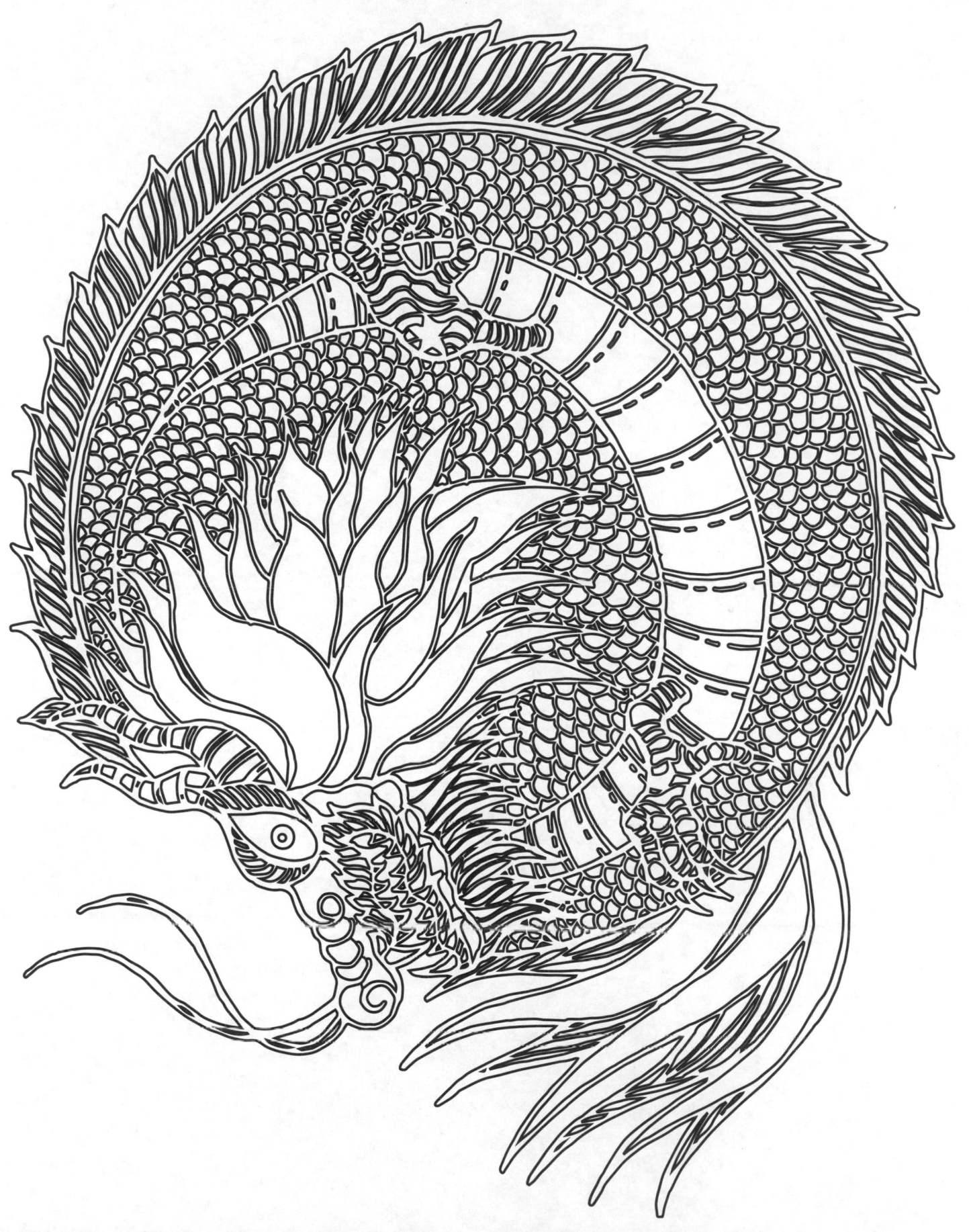

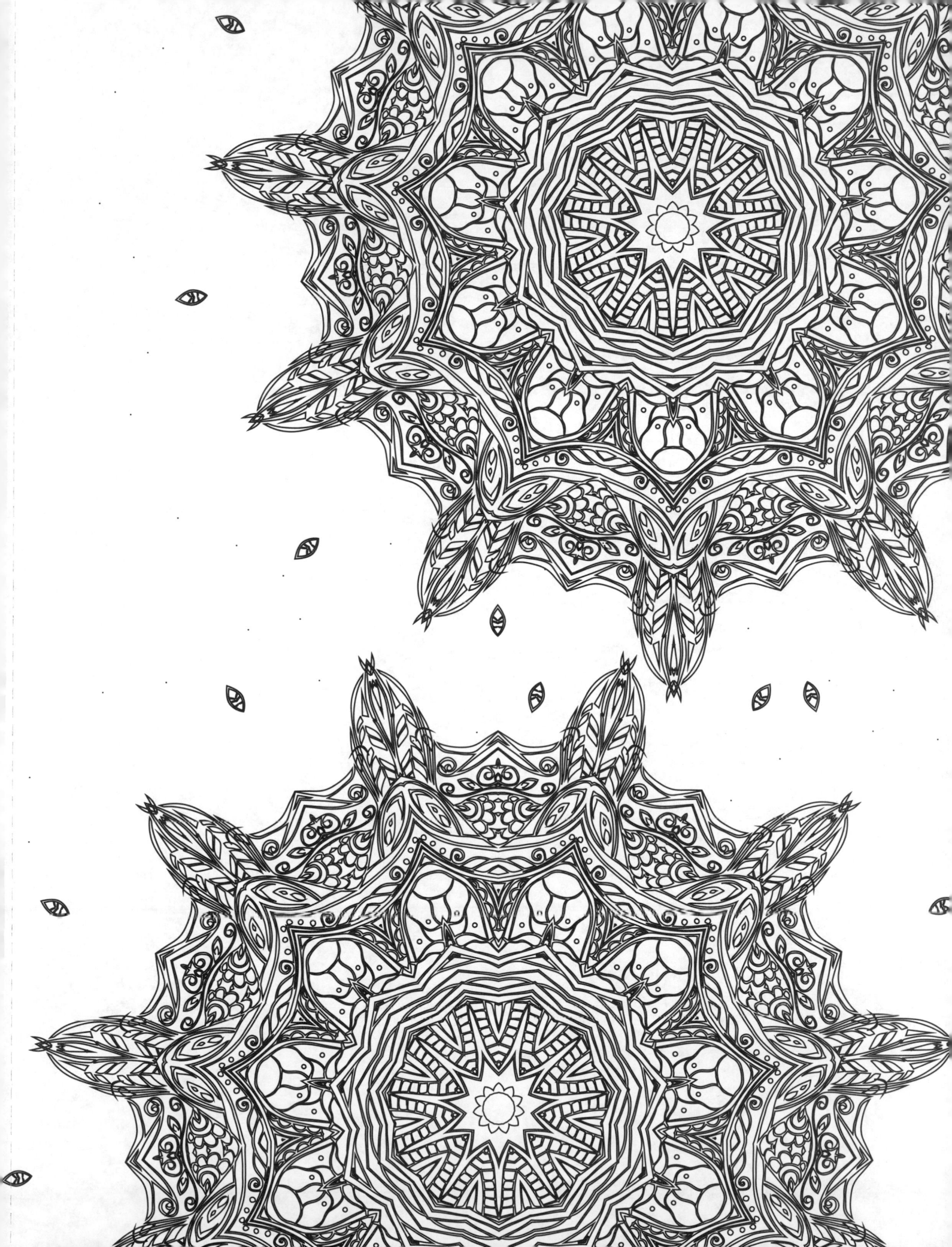

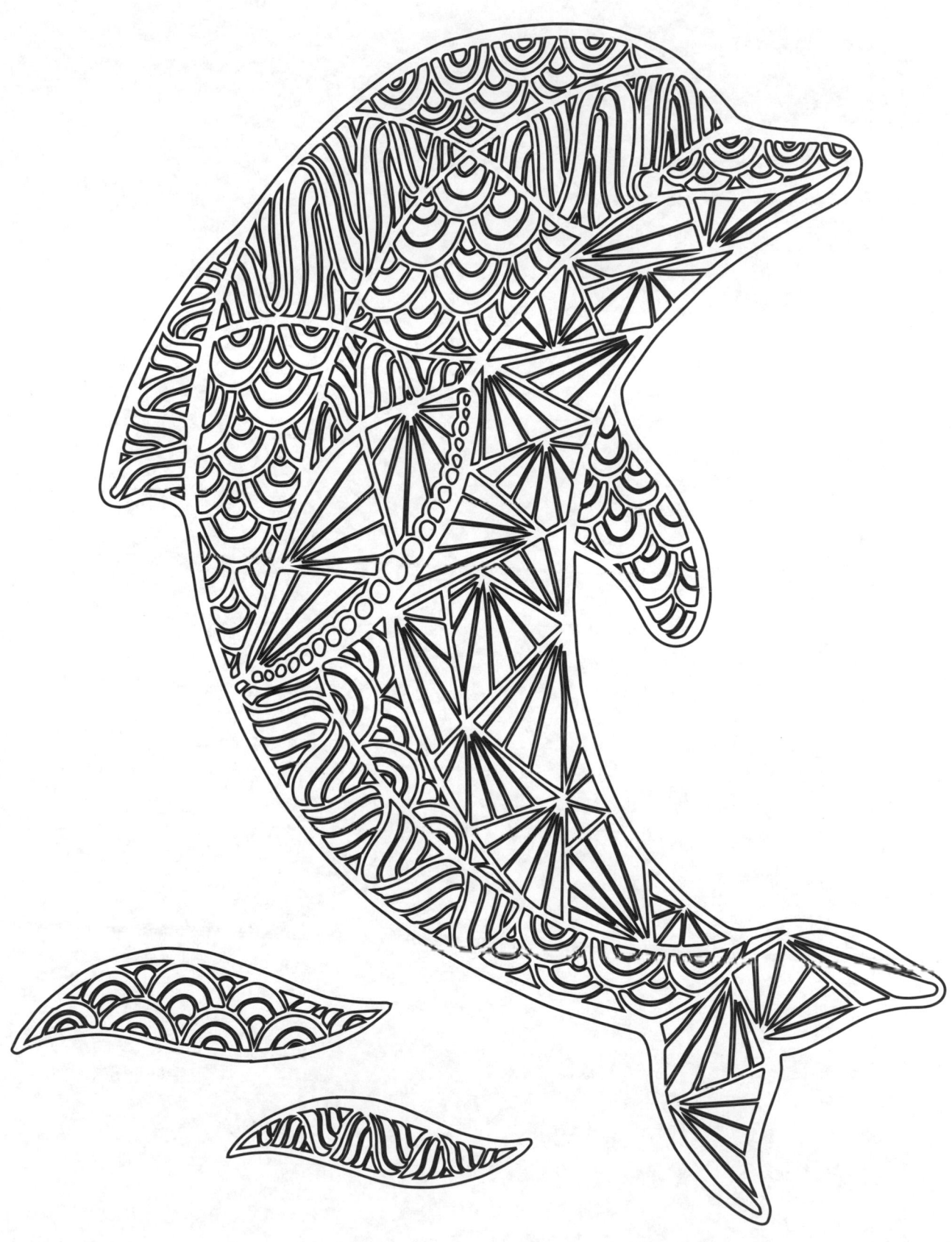

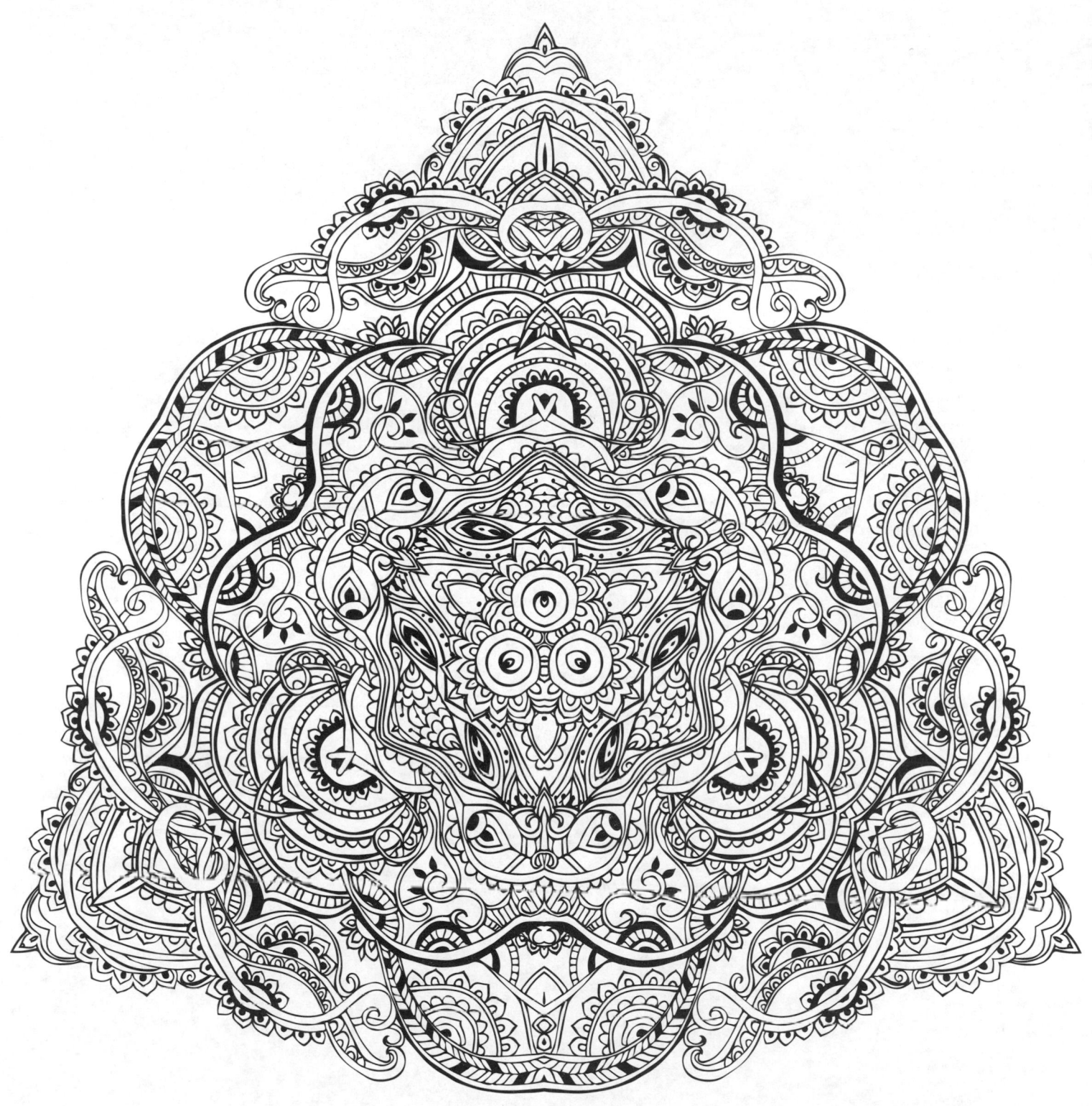

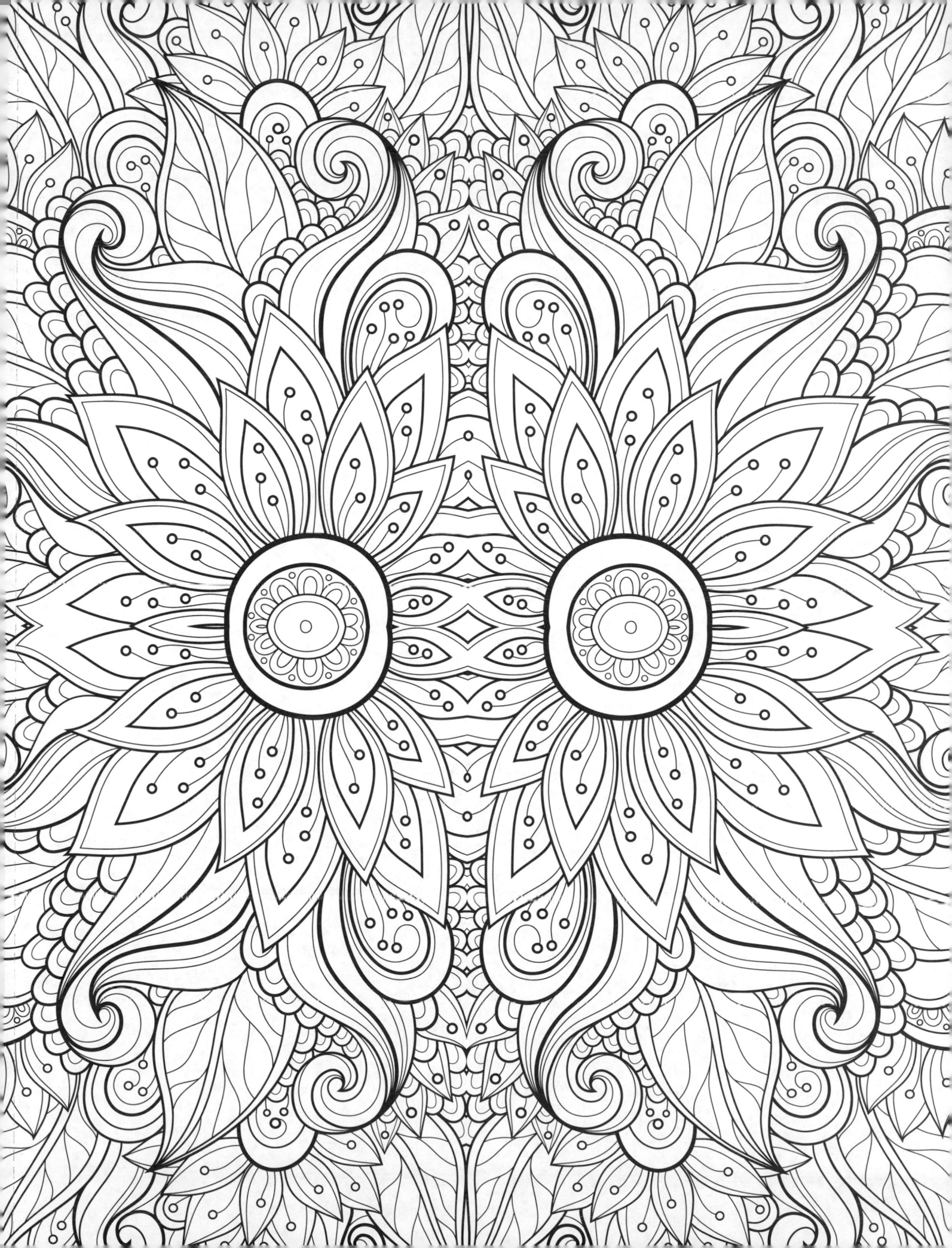

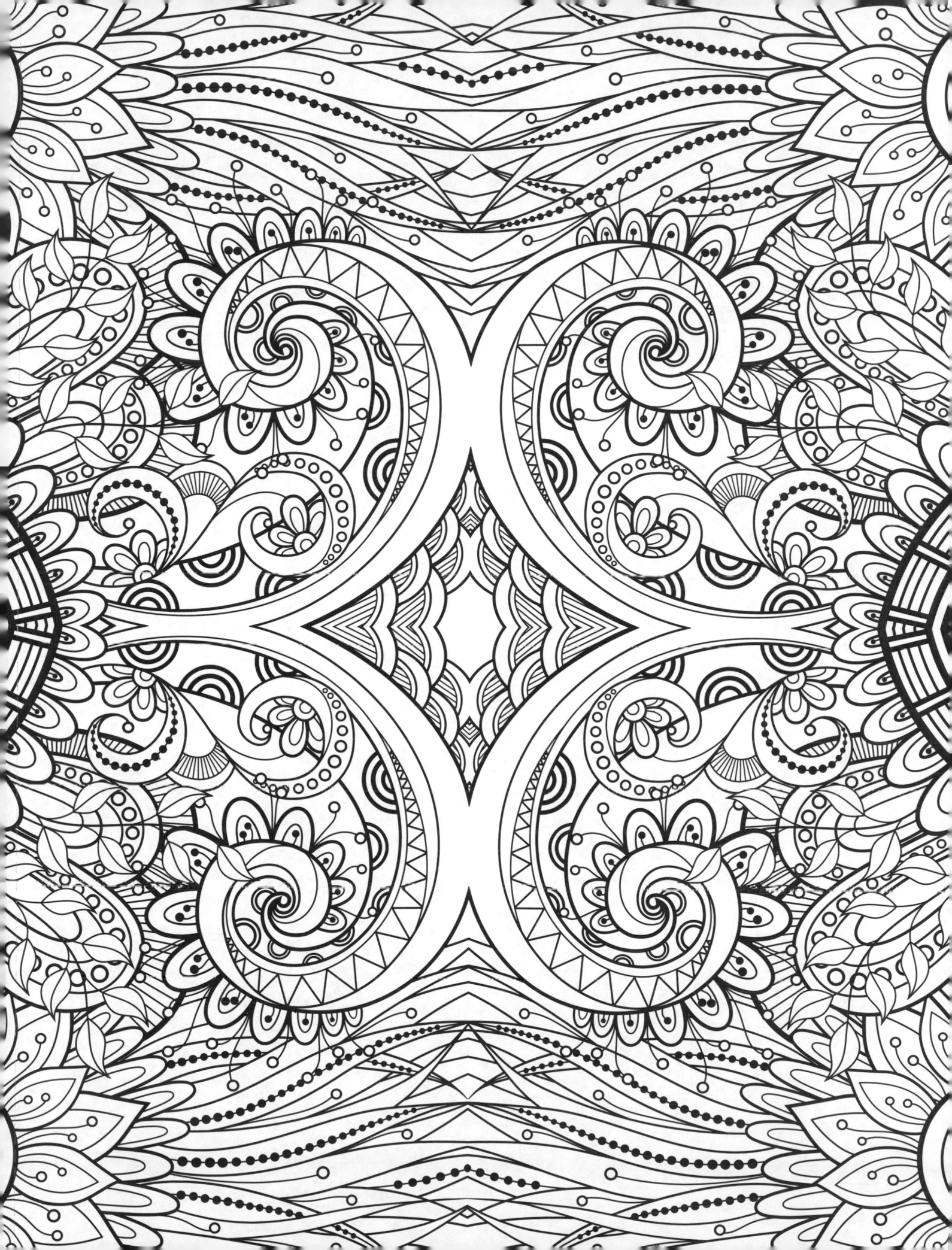

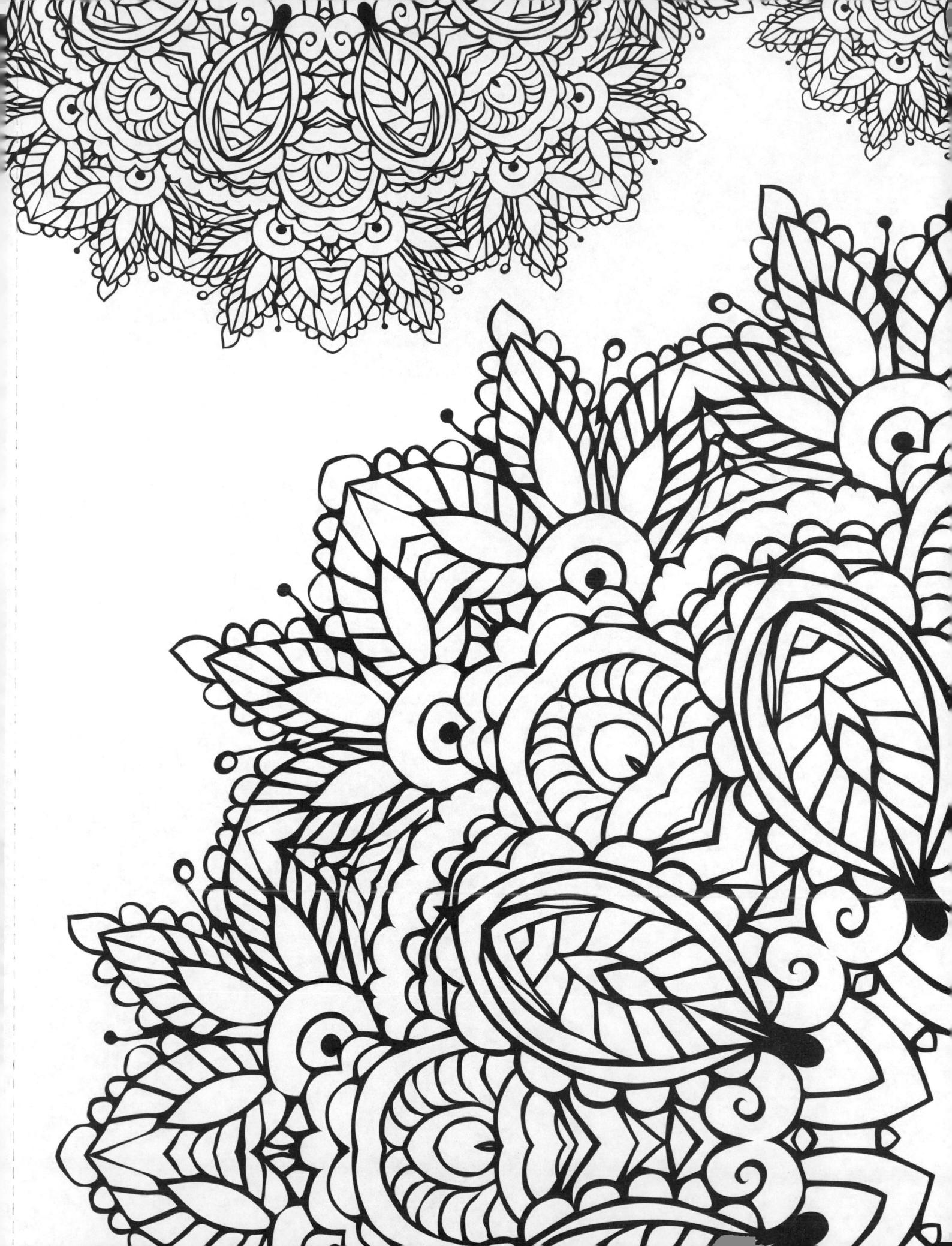

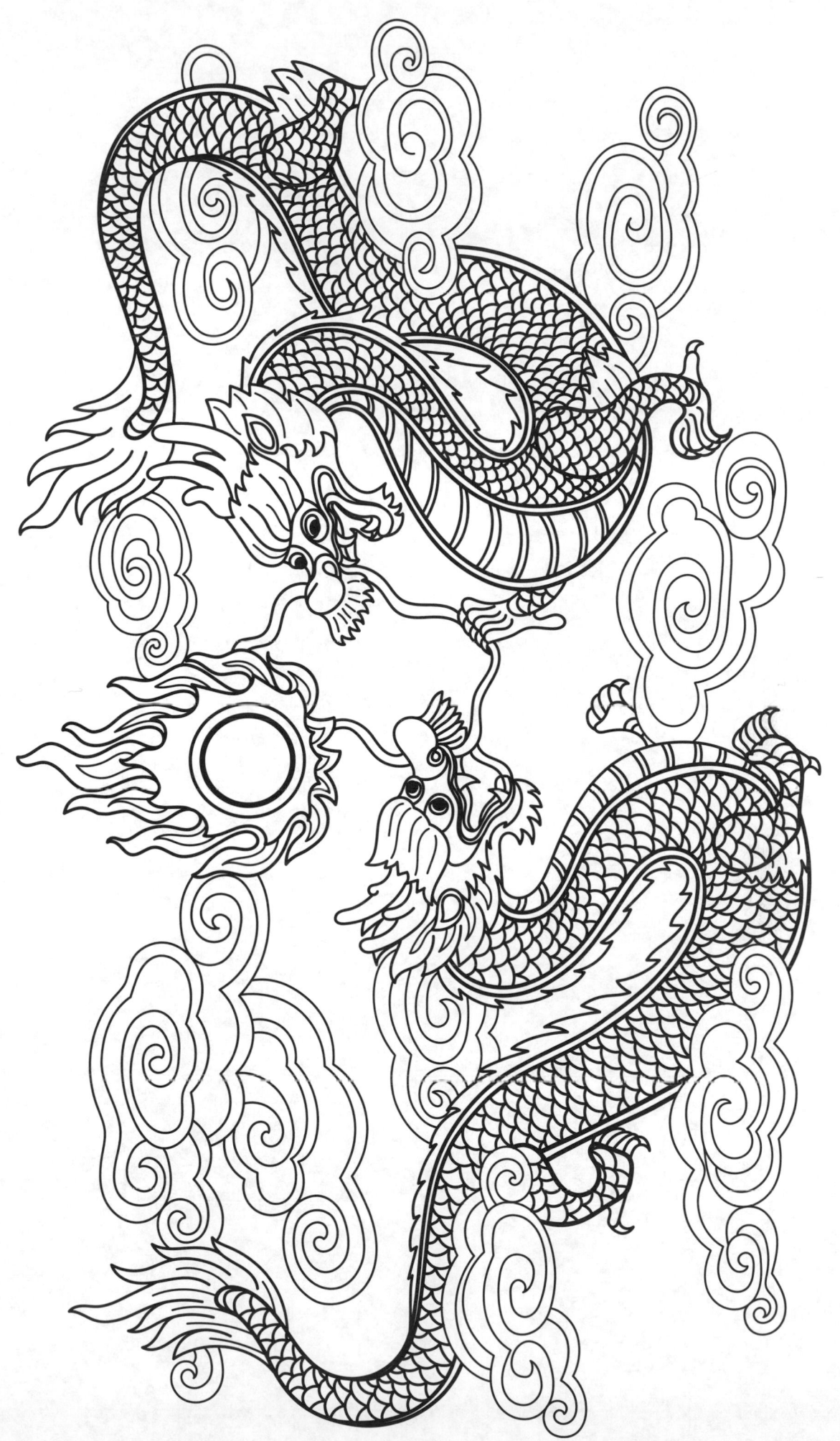

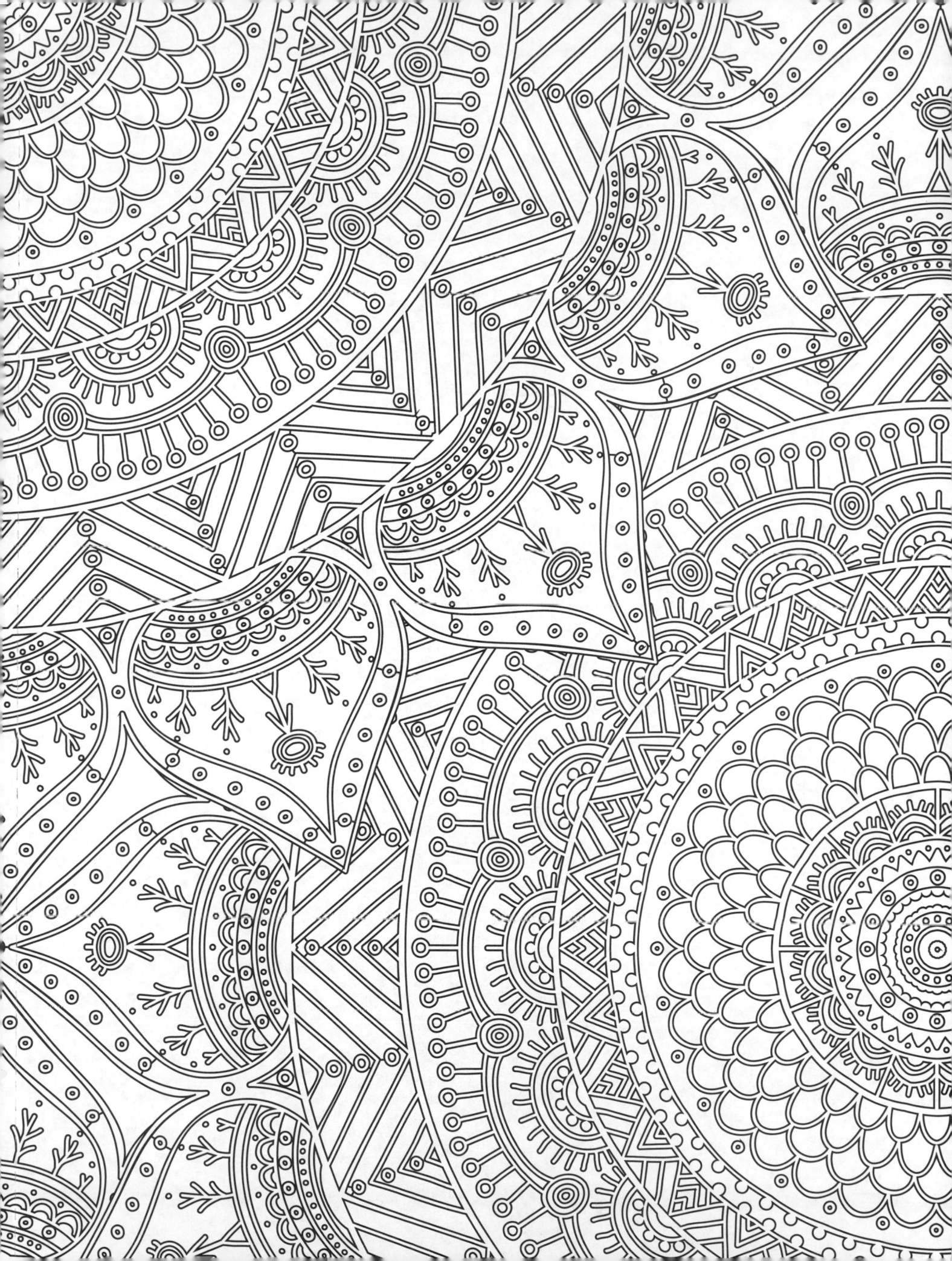

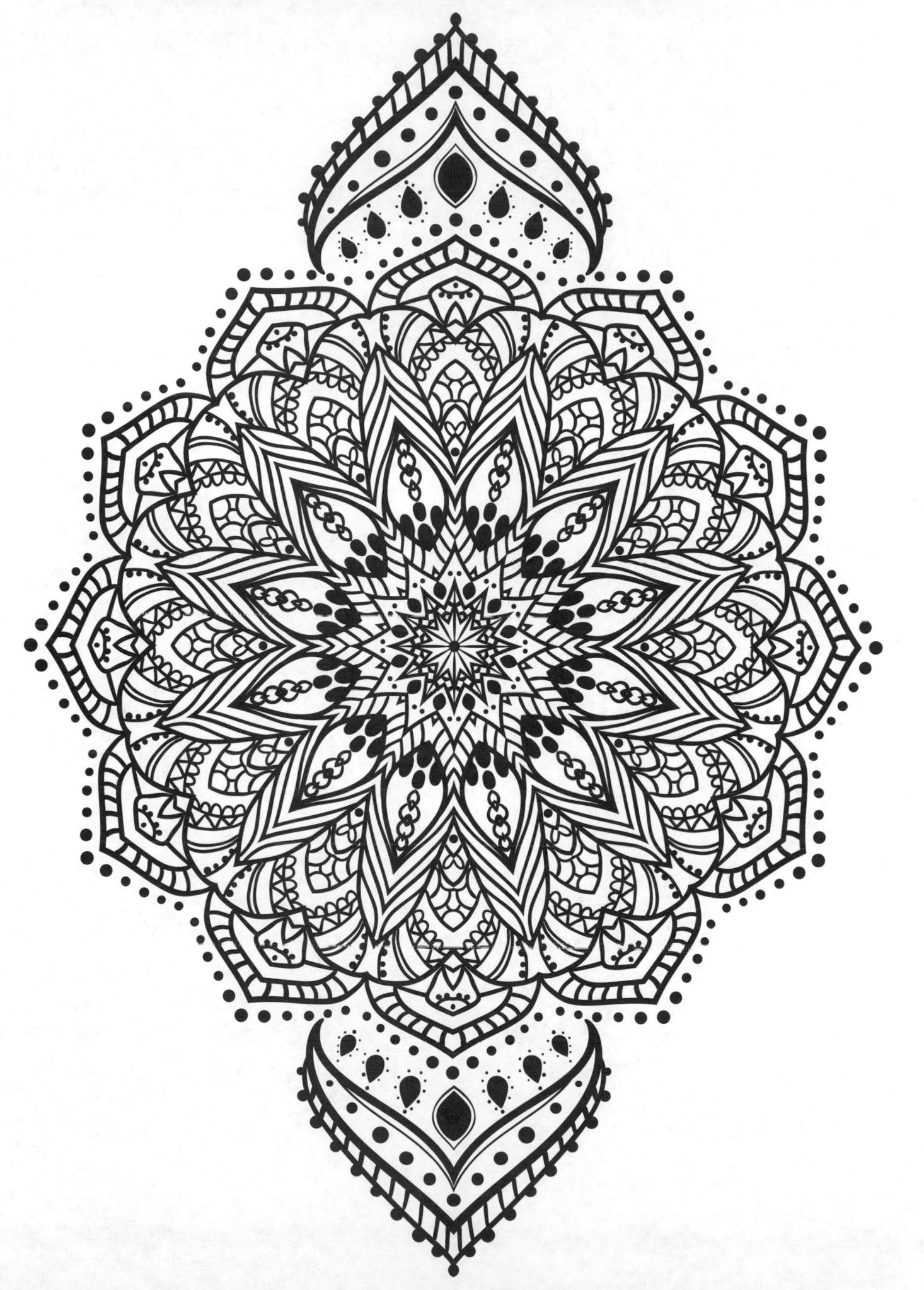

11

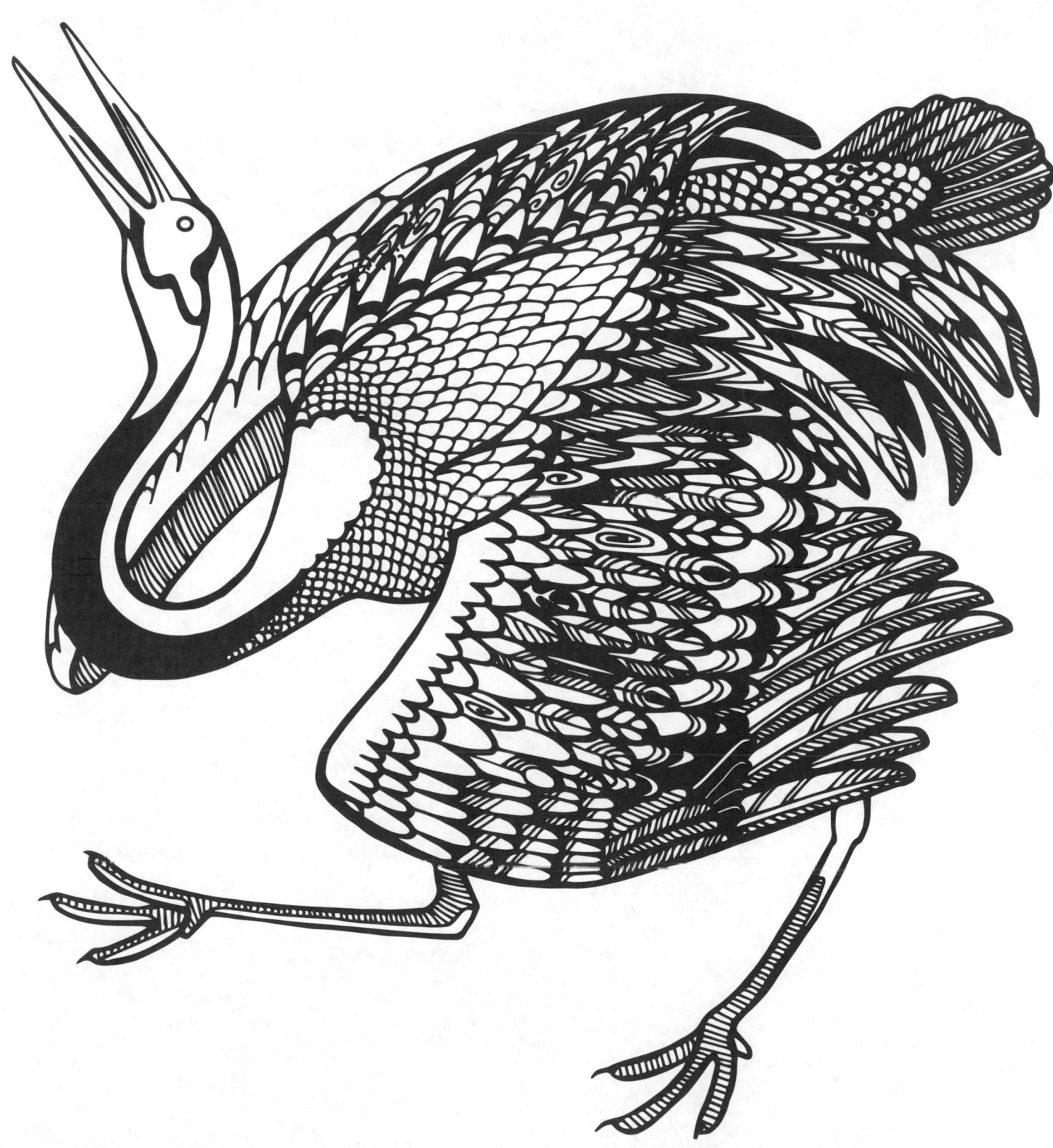

12

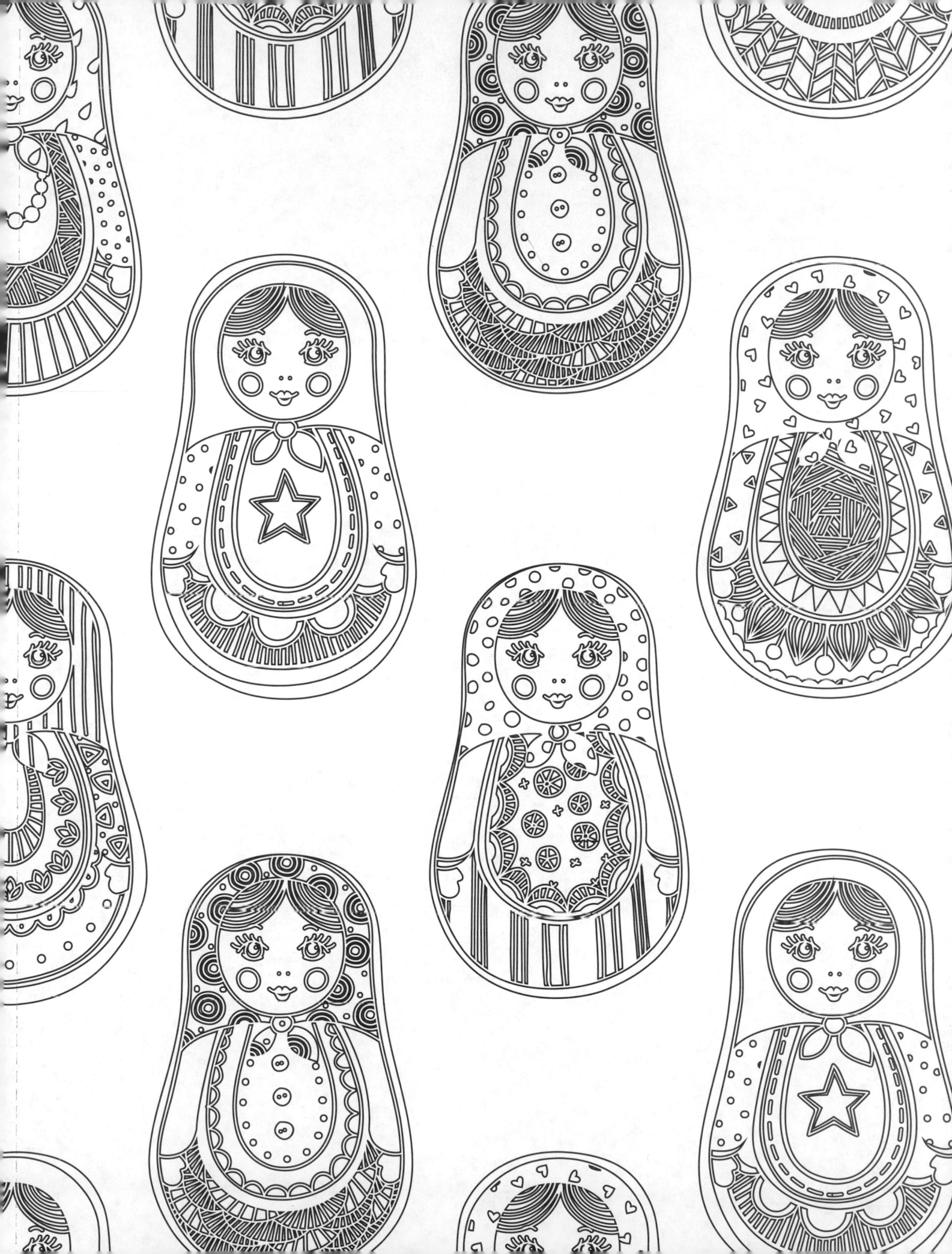

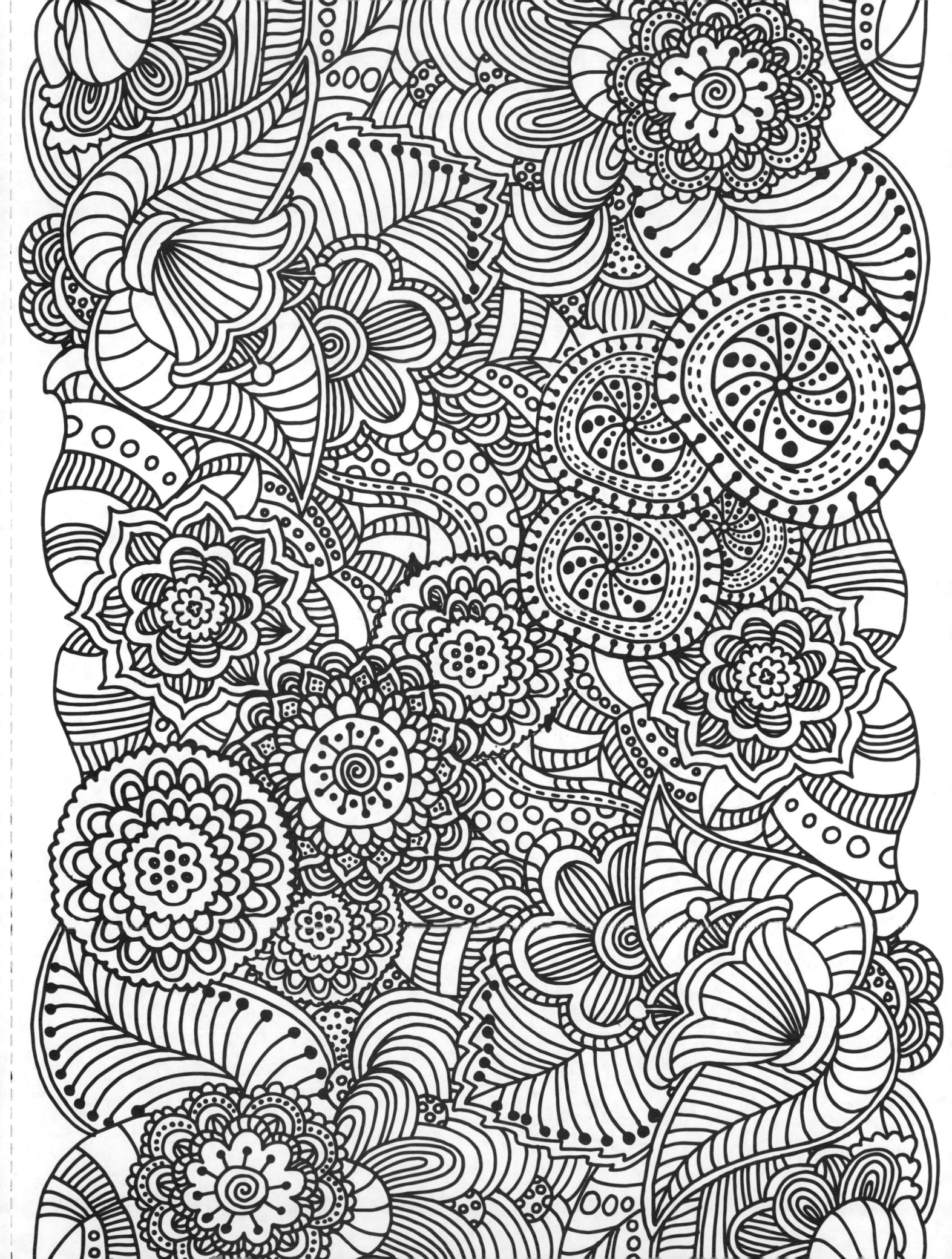

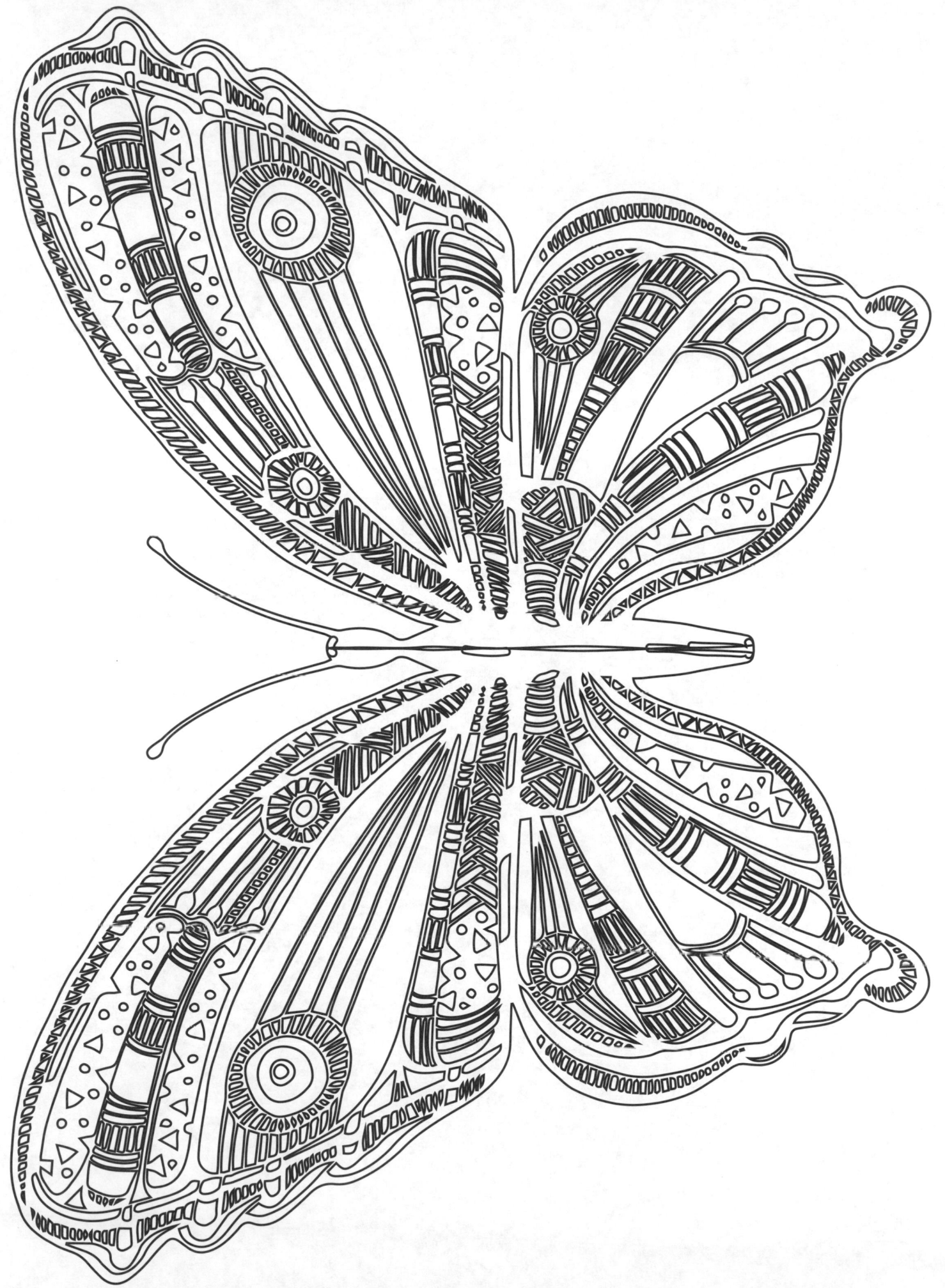

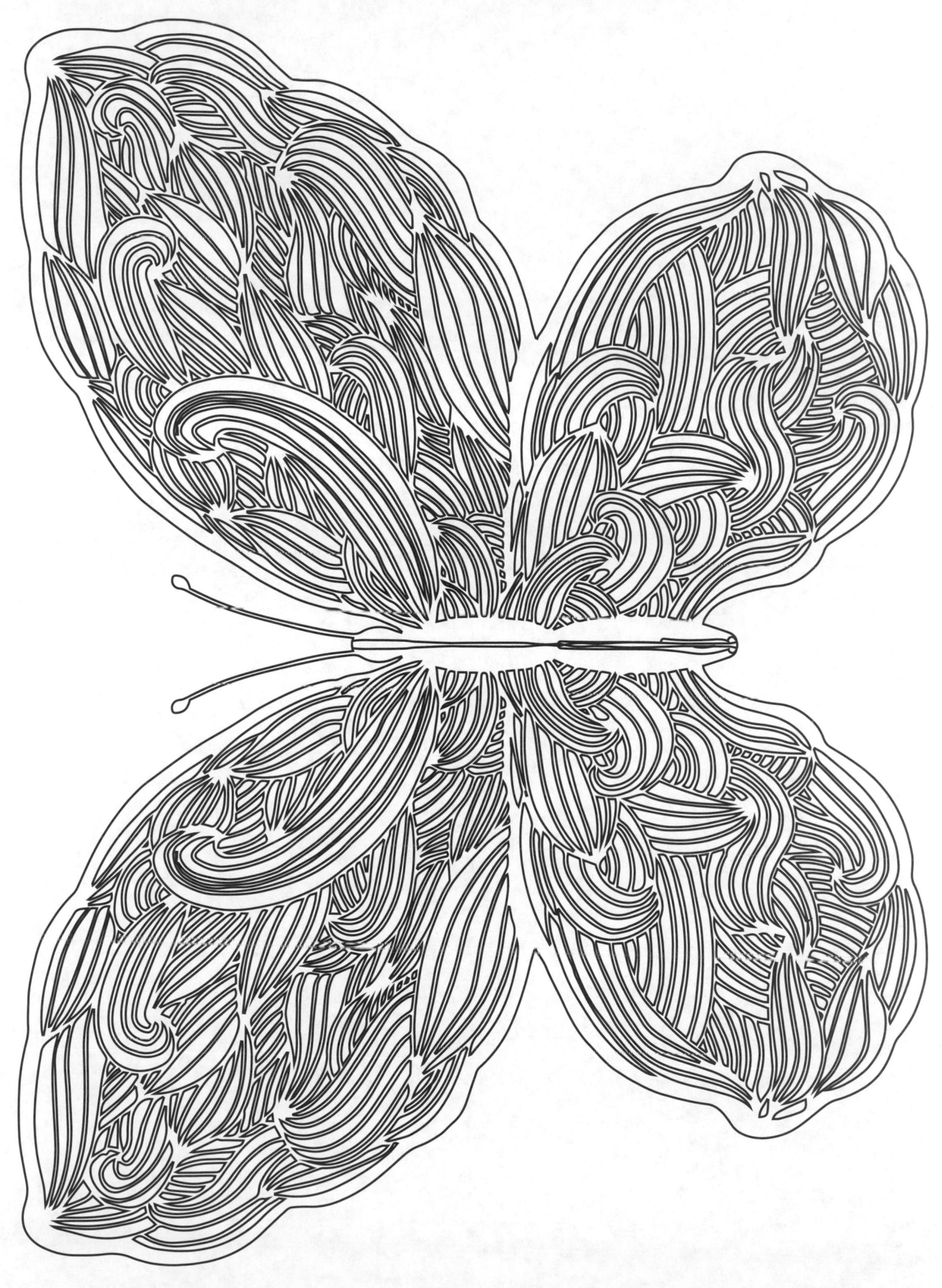

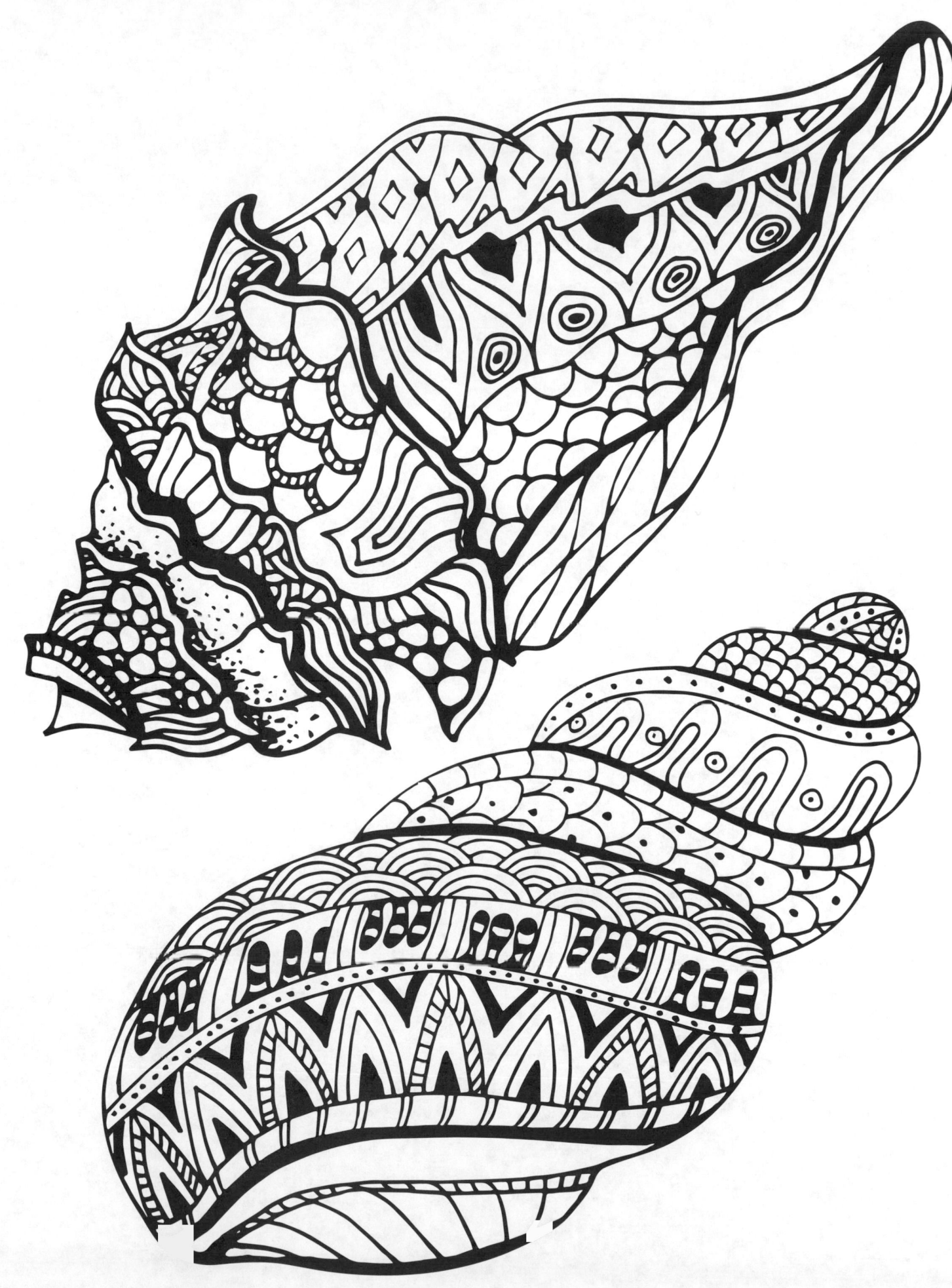

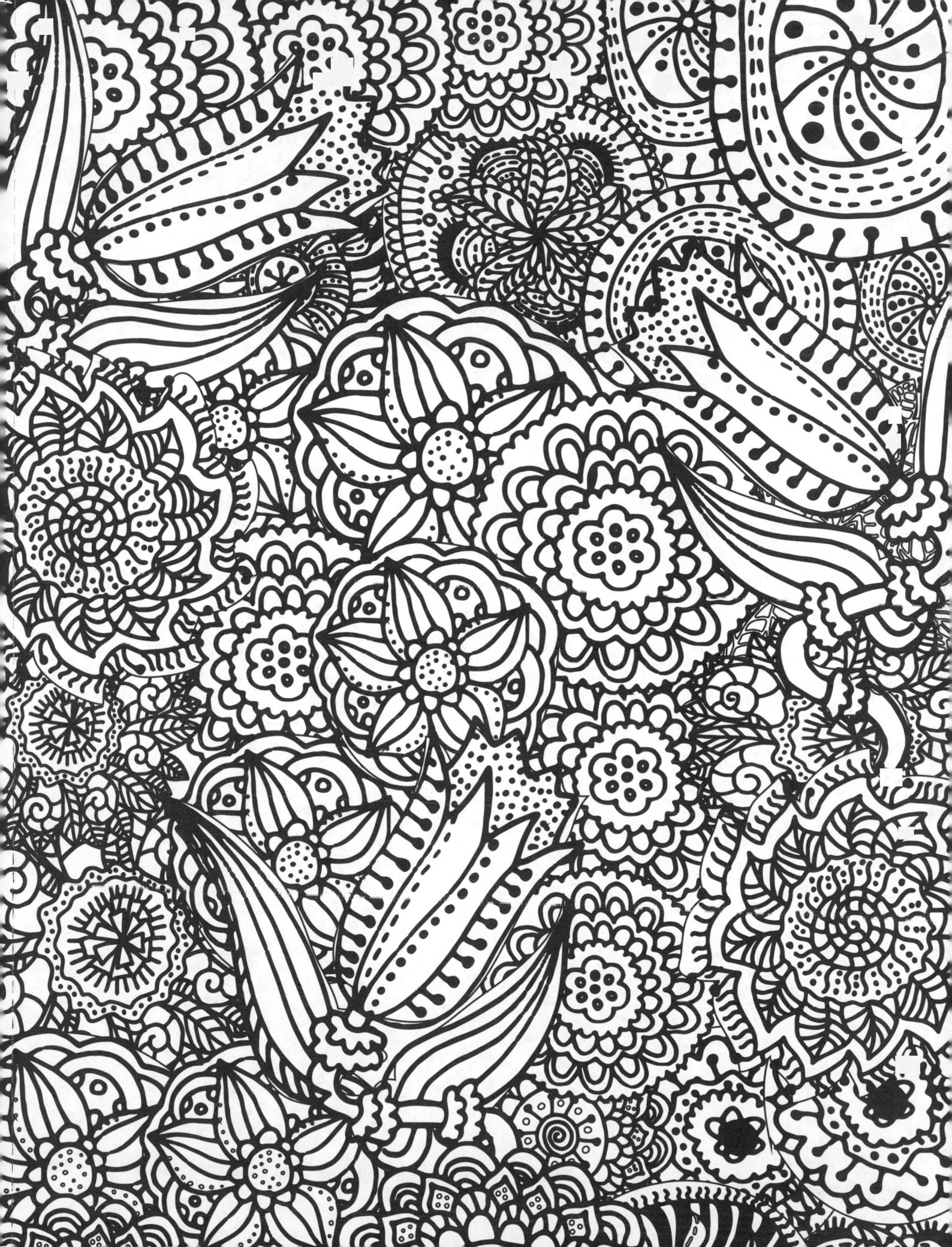

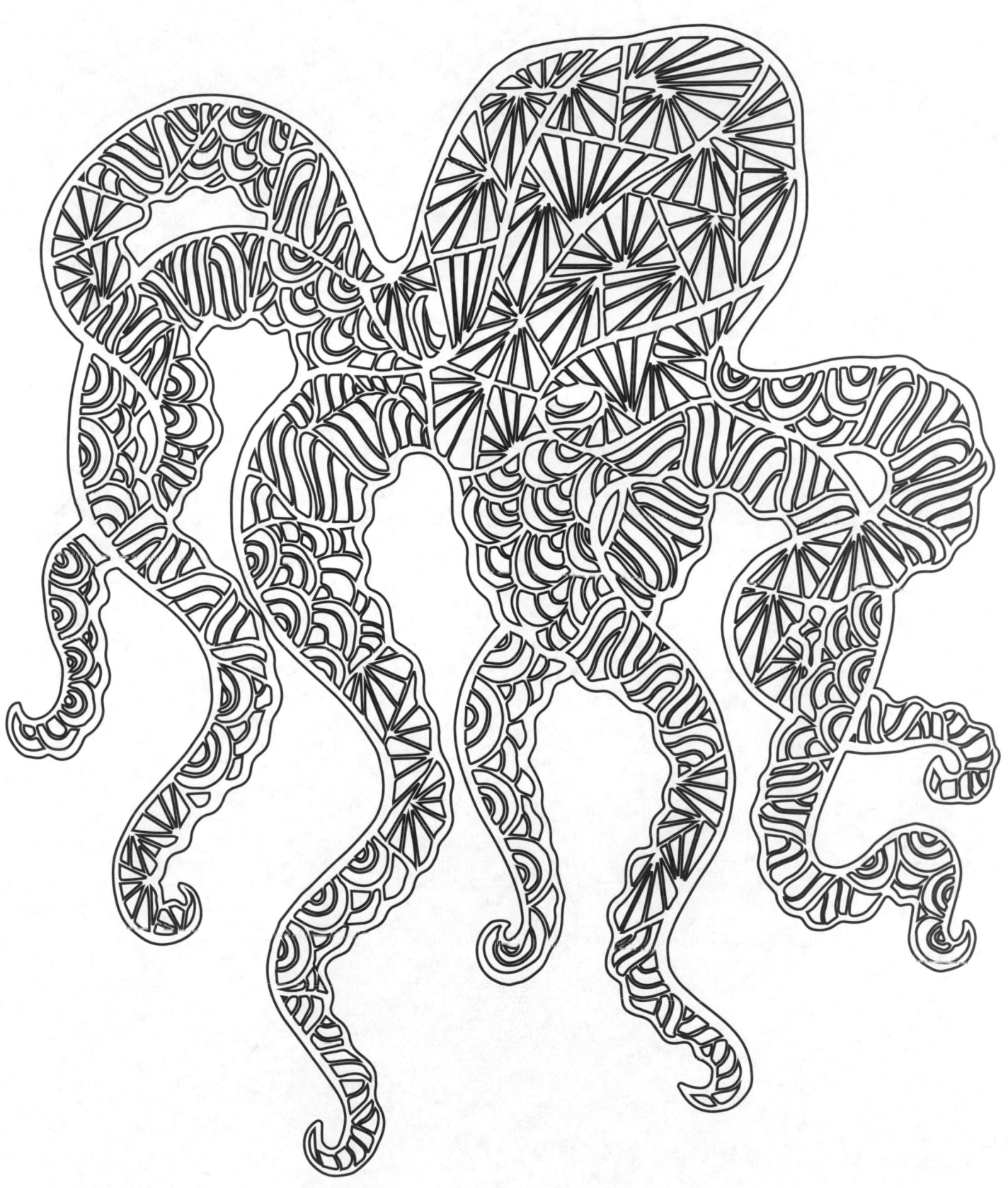

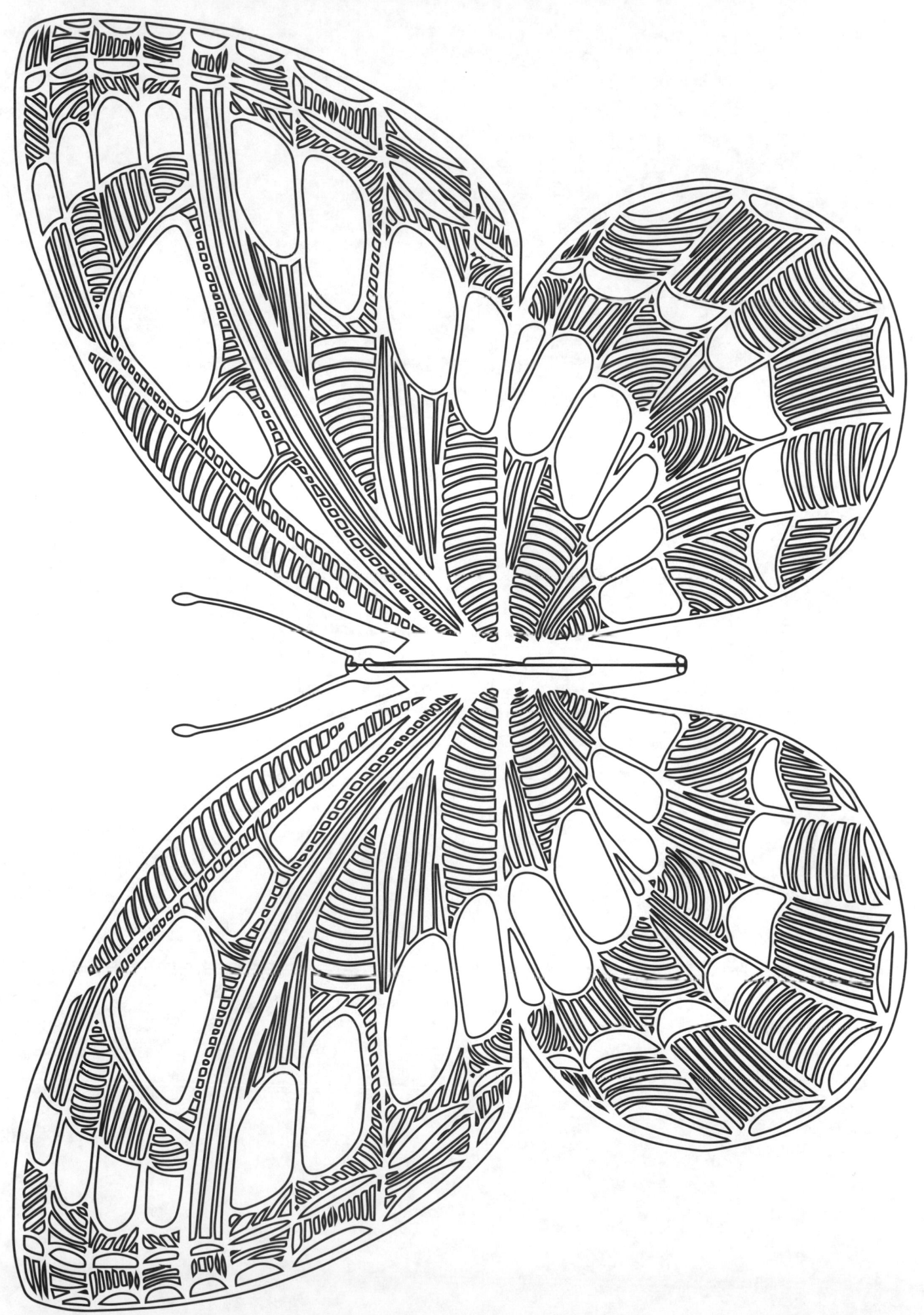

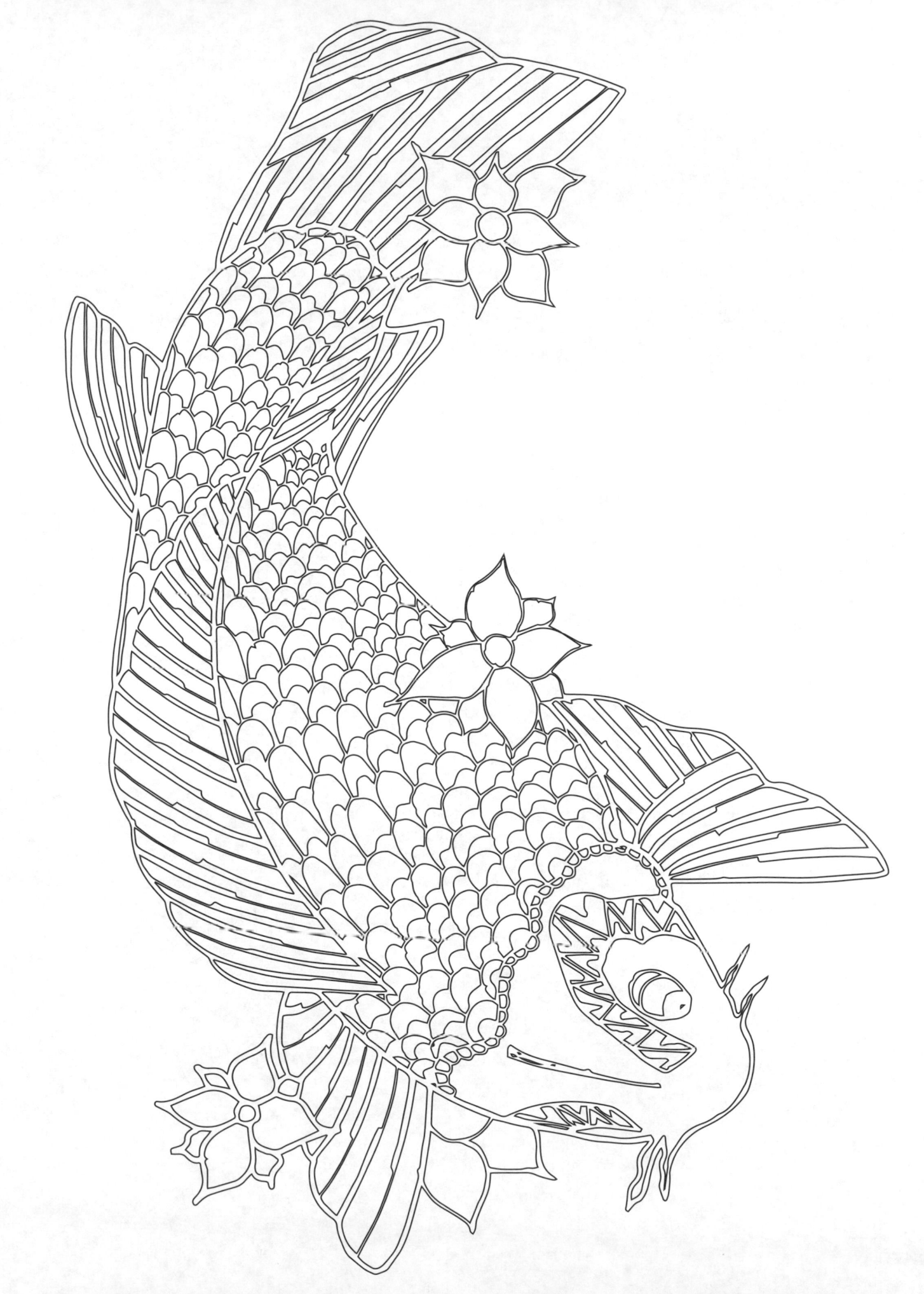

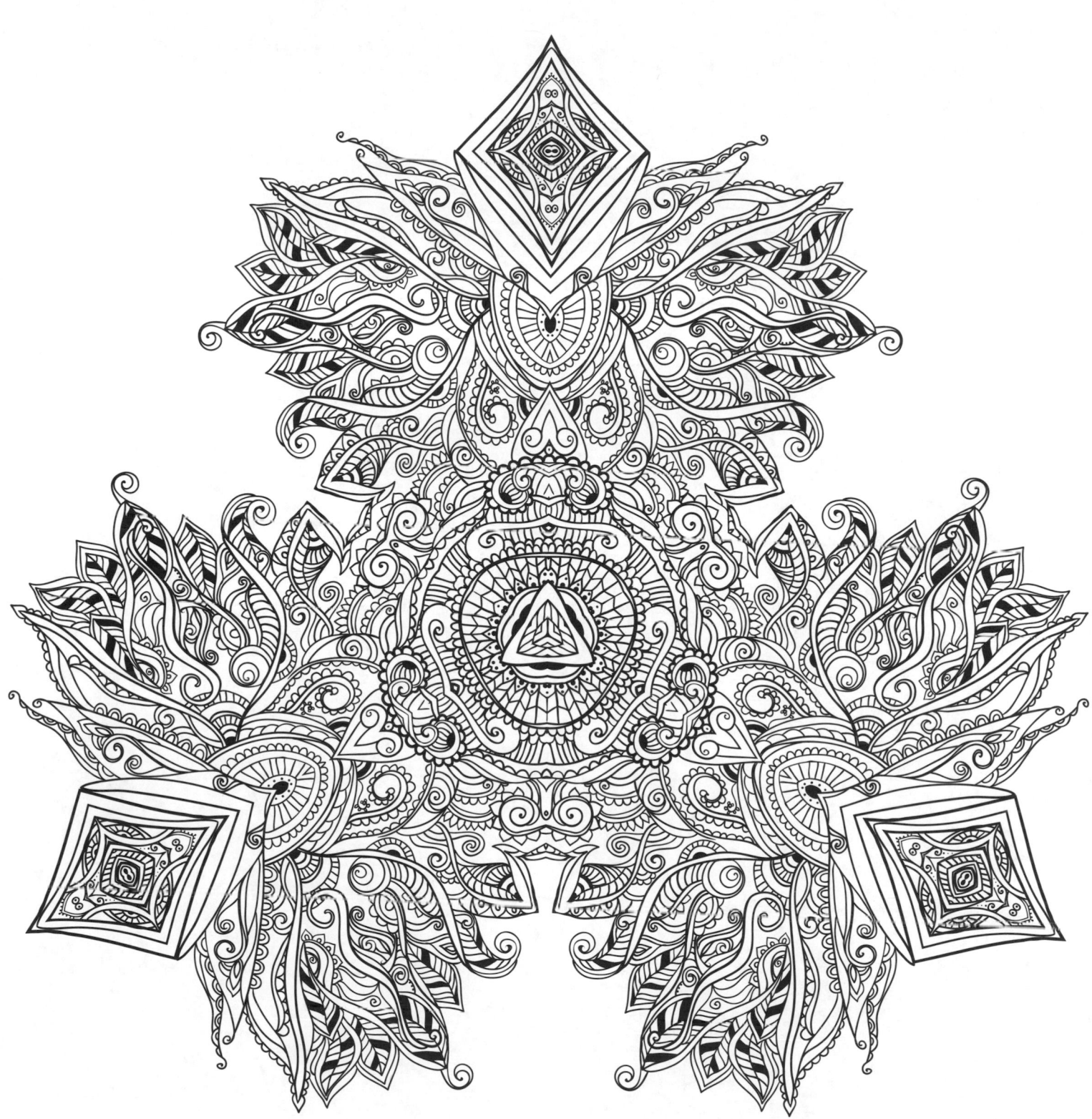

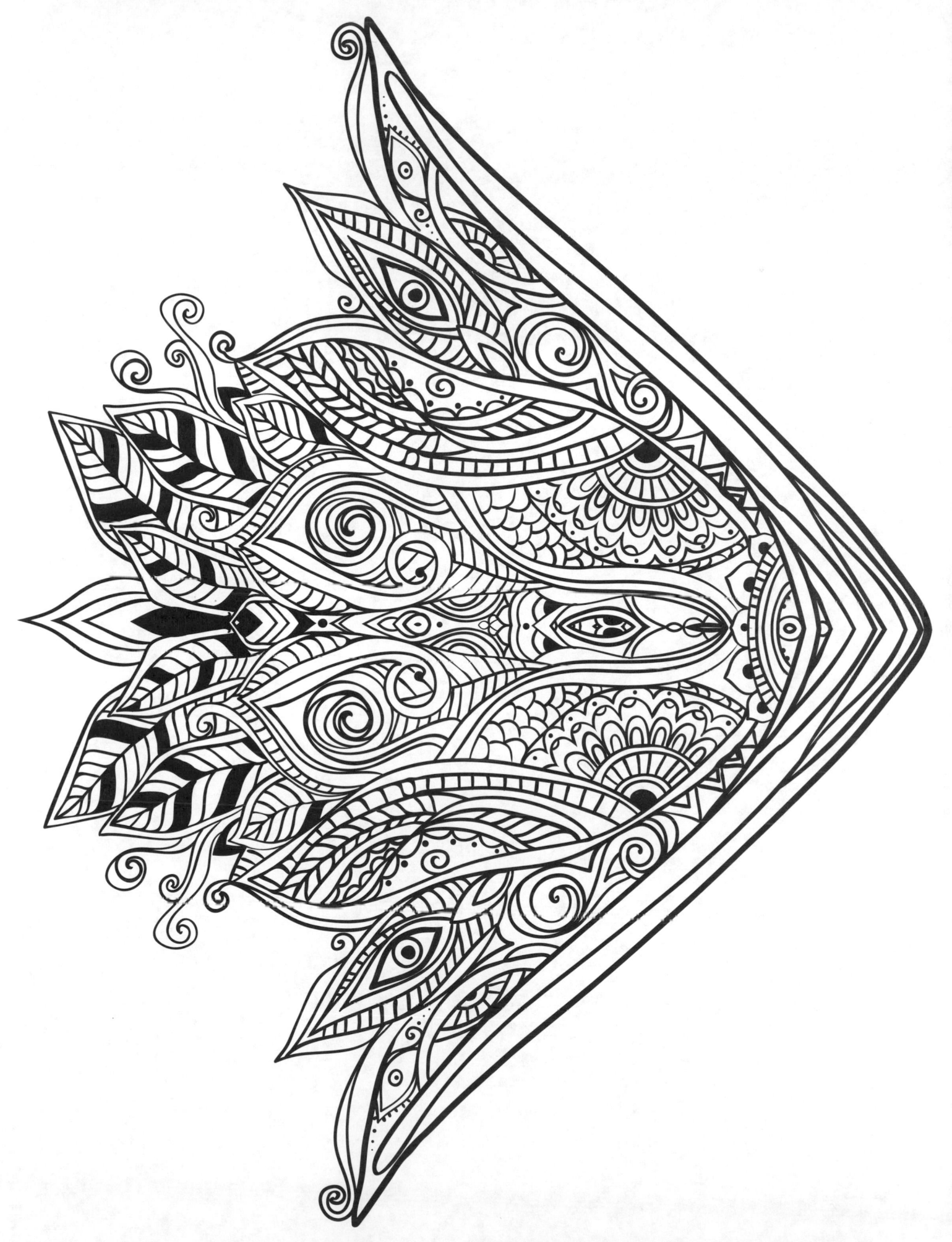

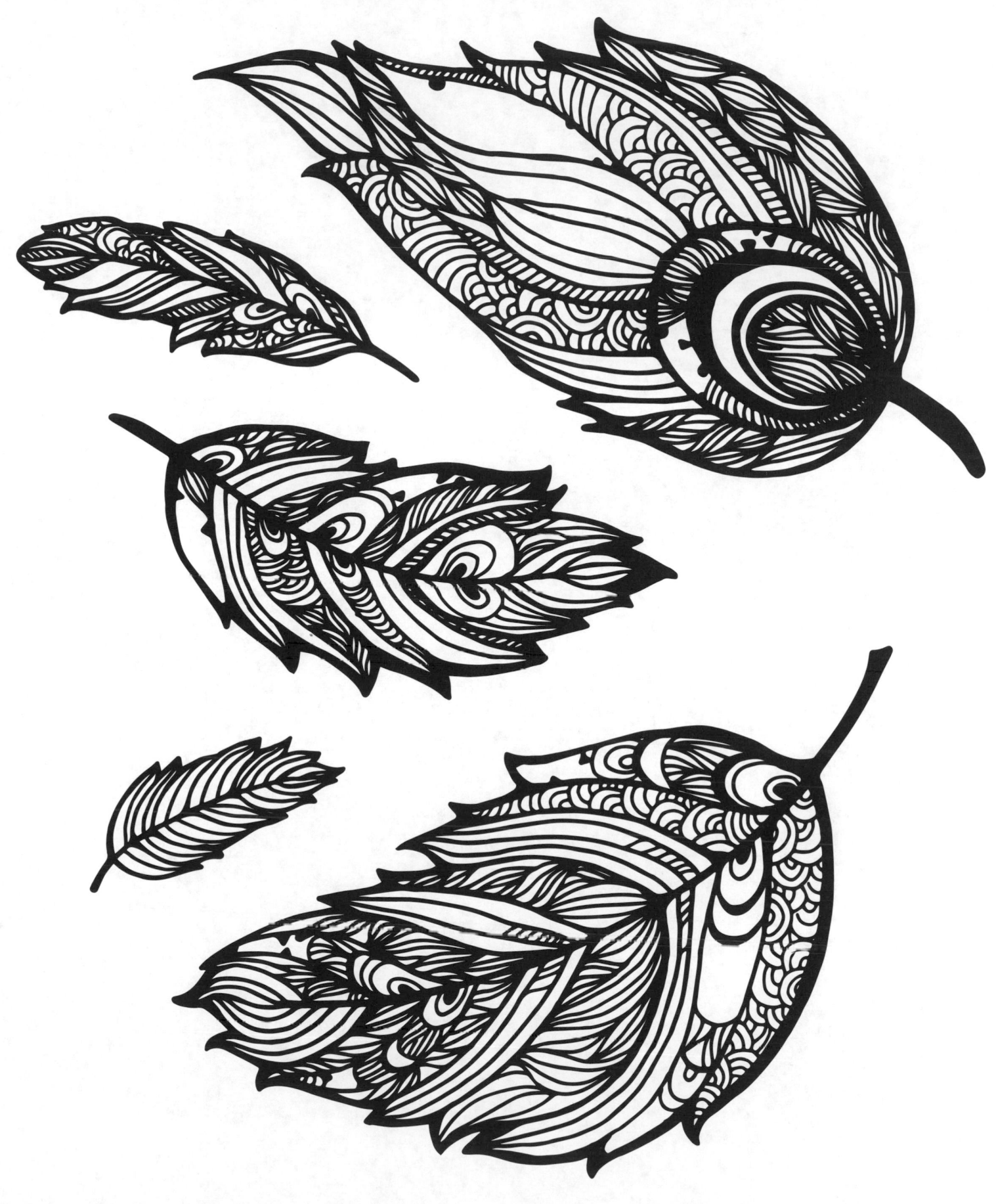

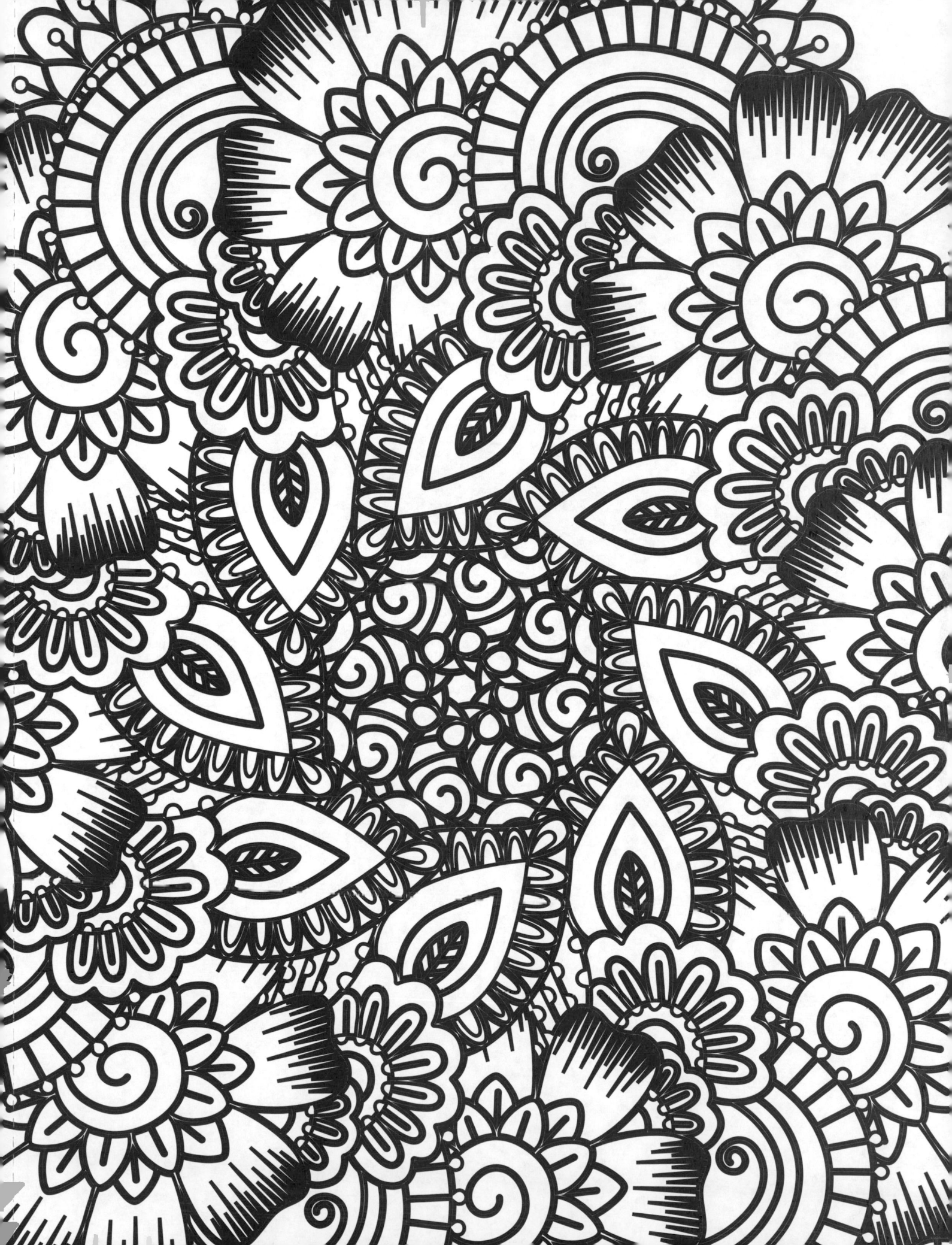

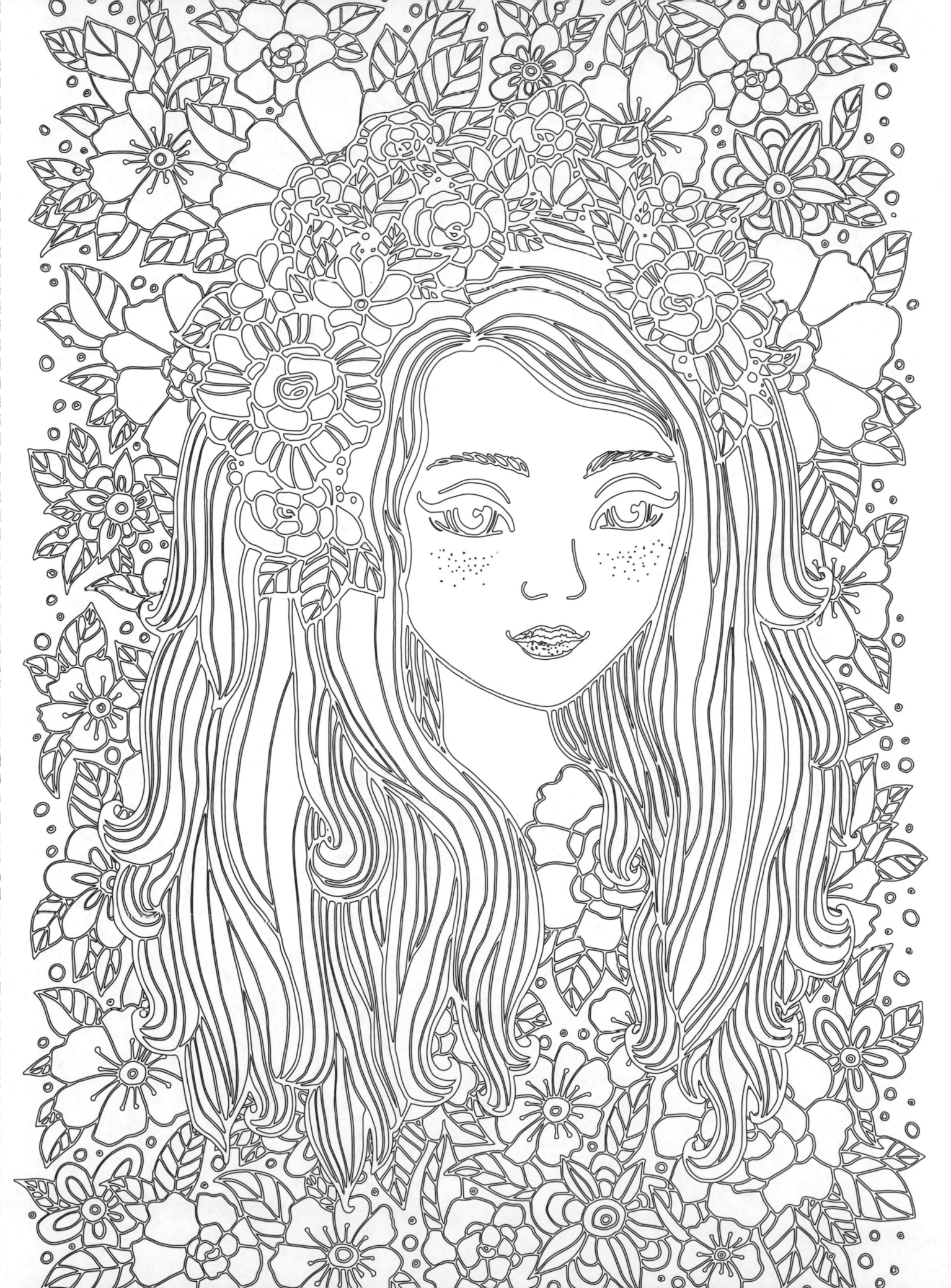

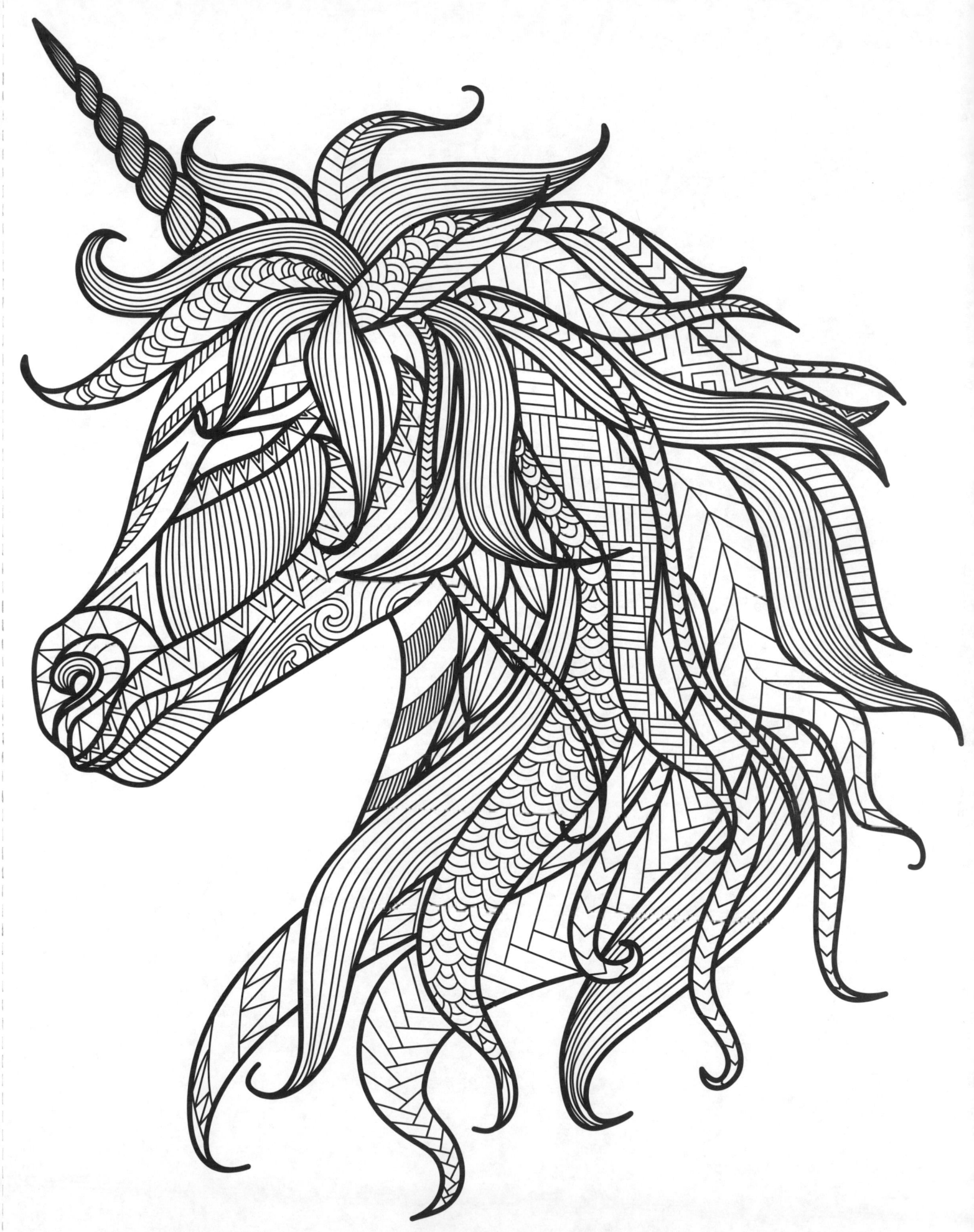

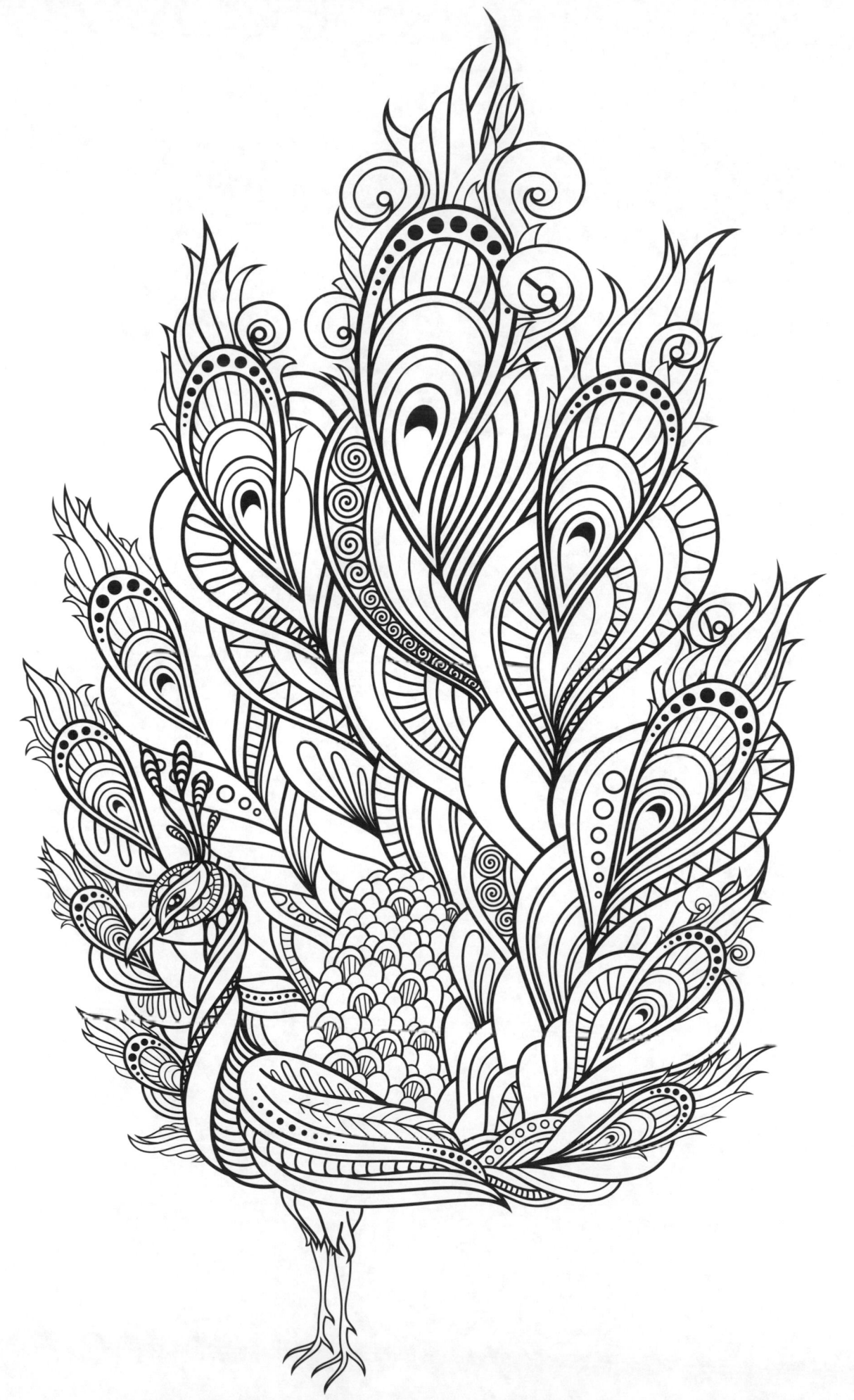

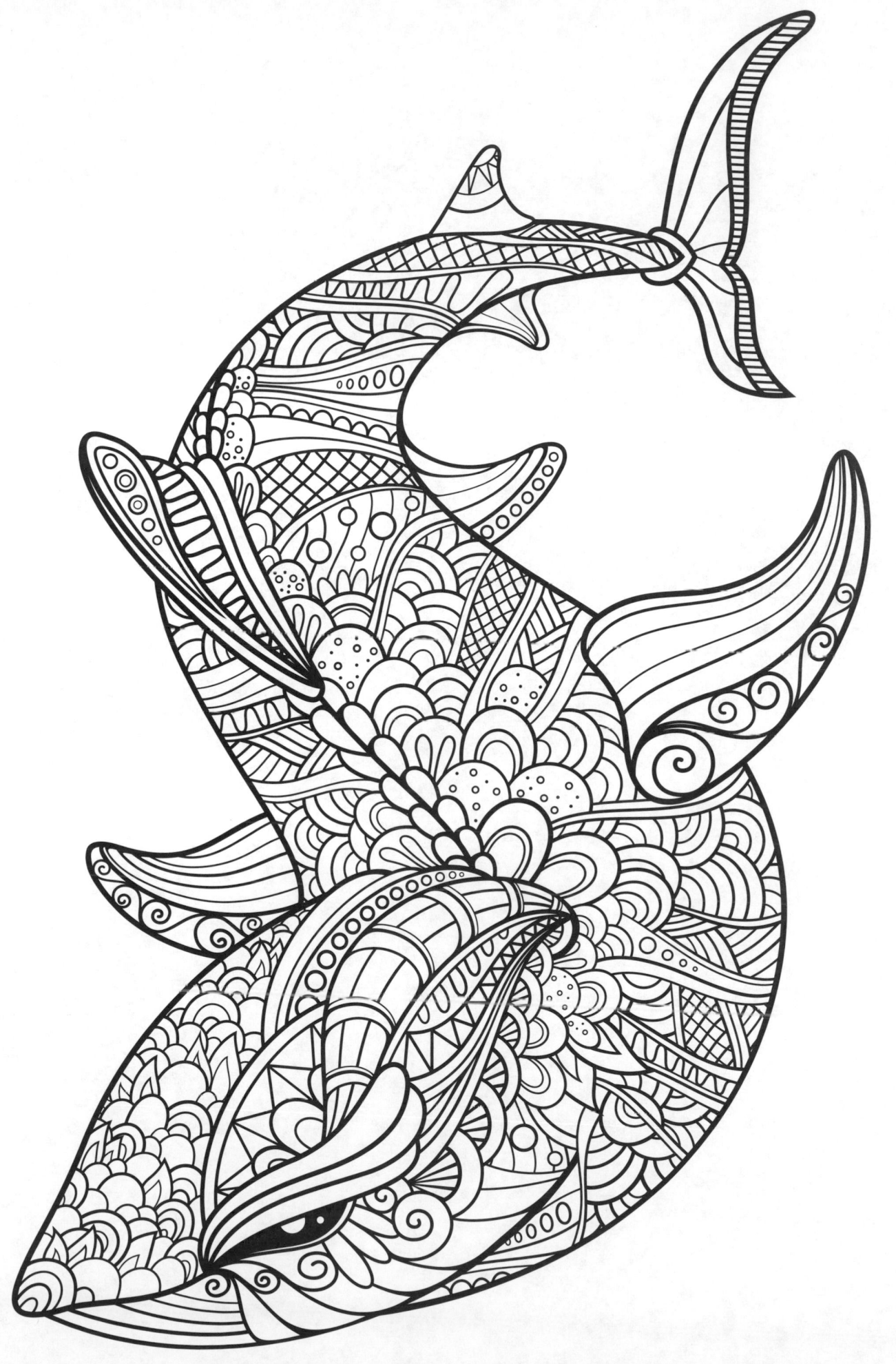

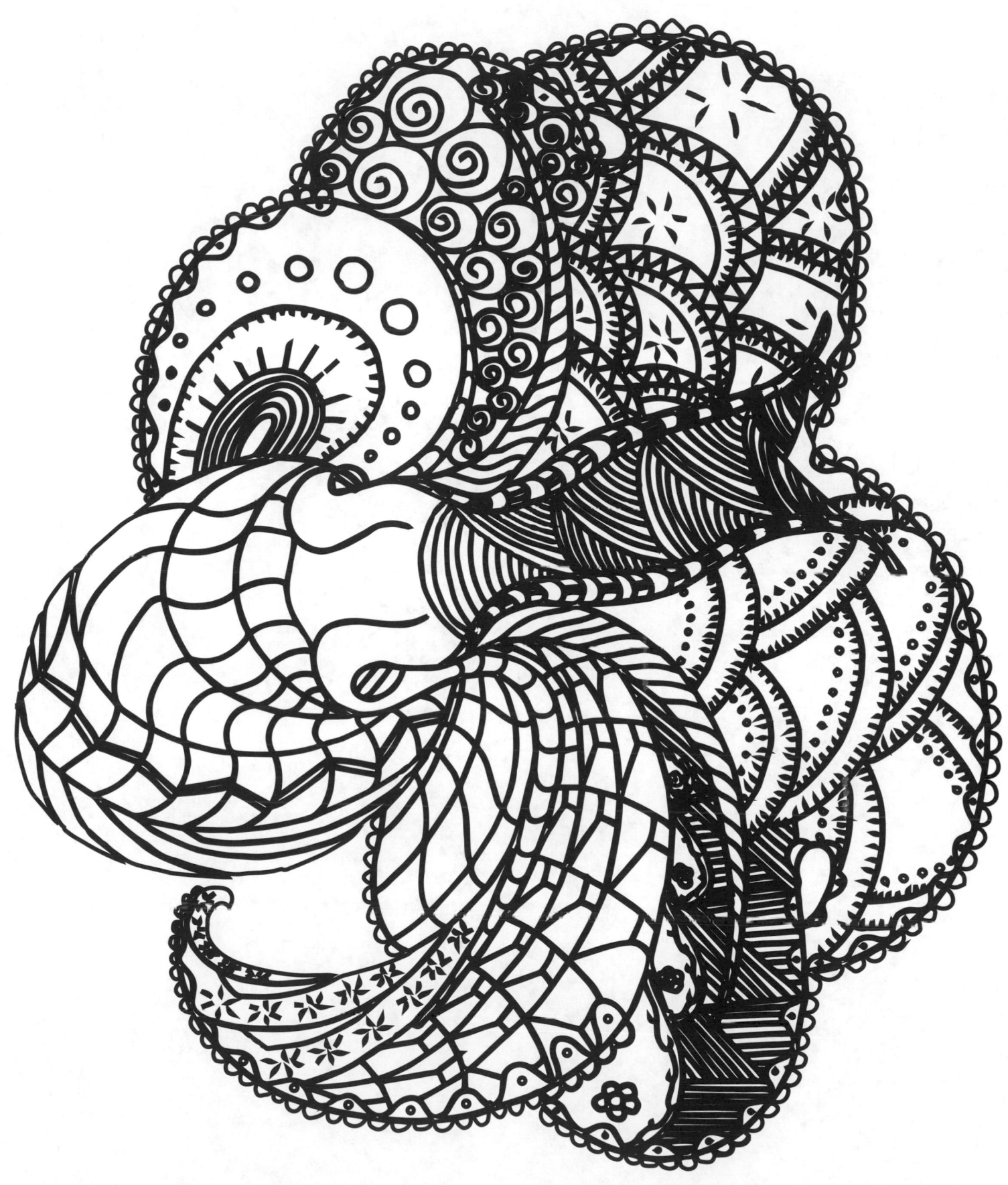

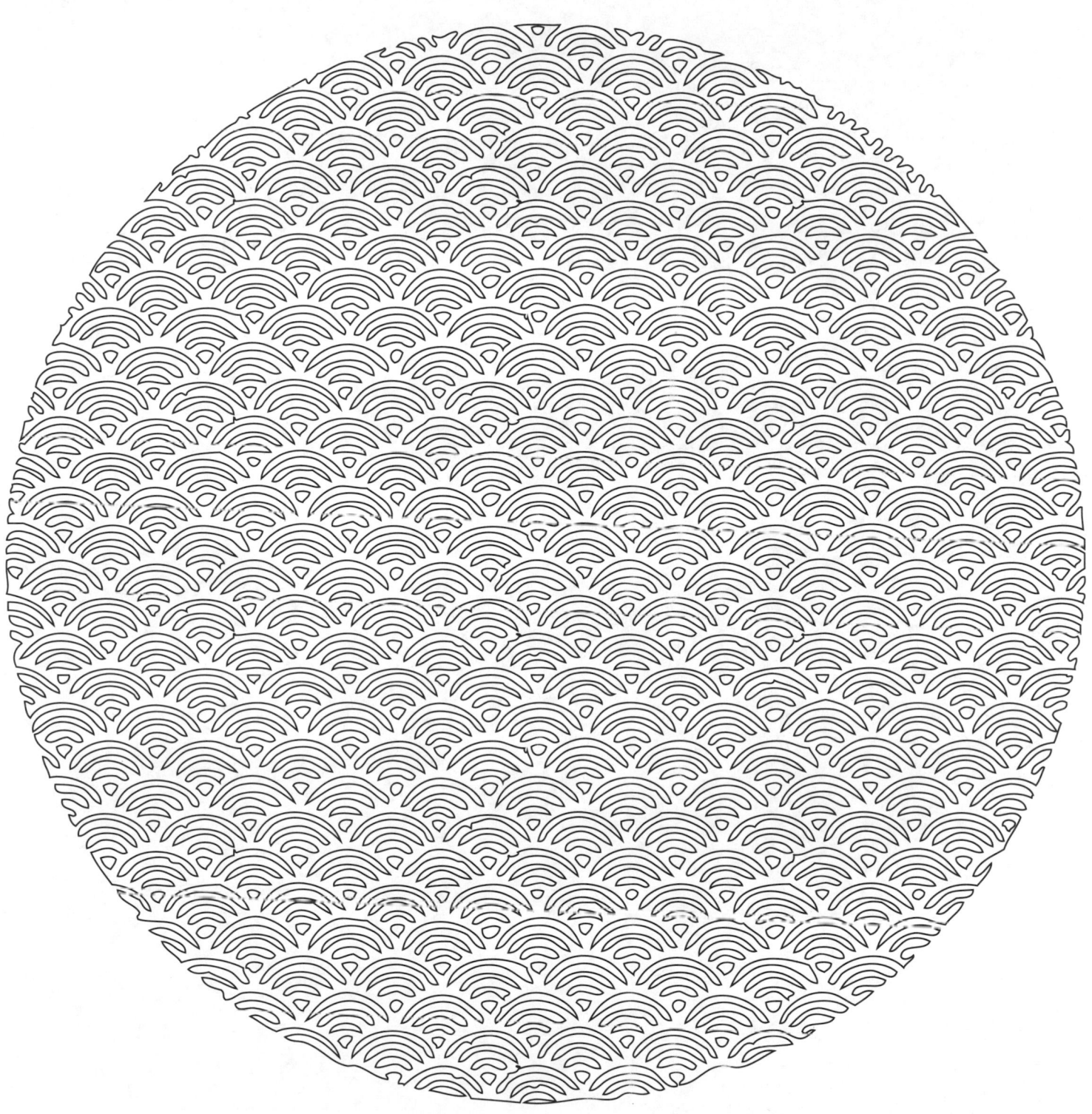

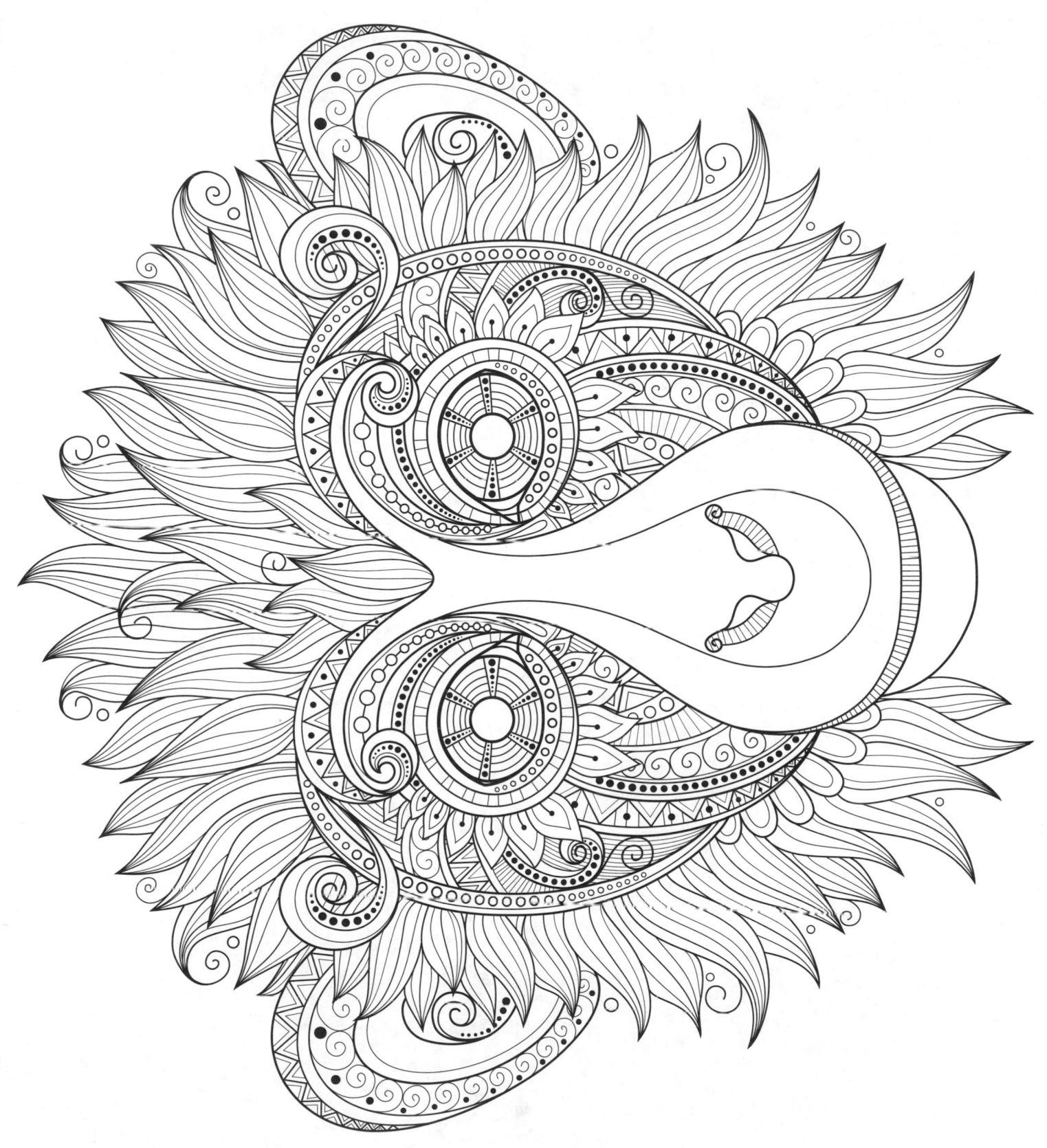

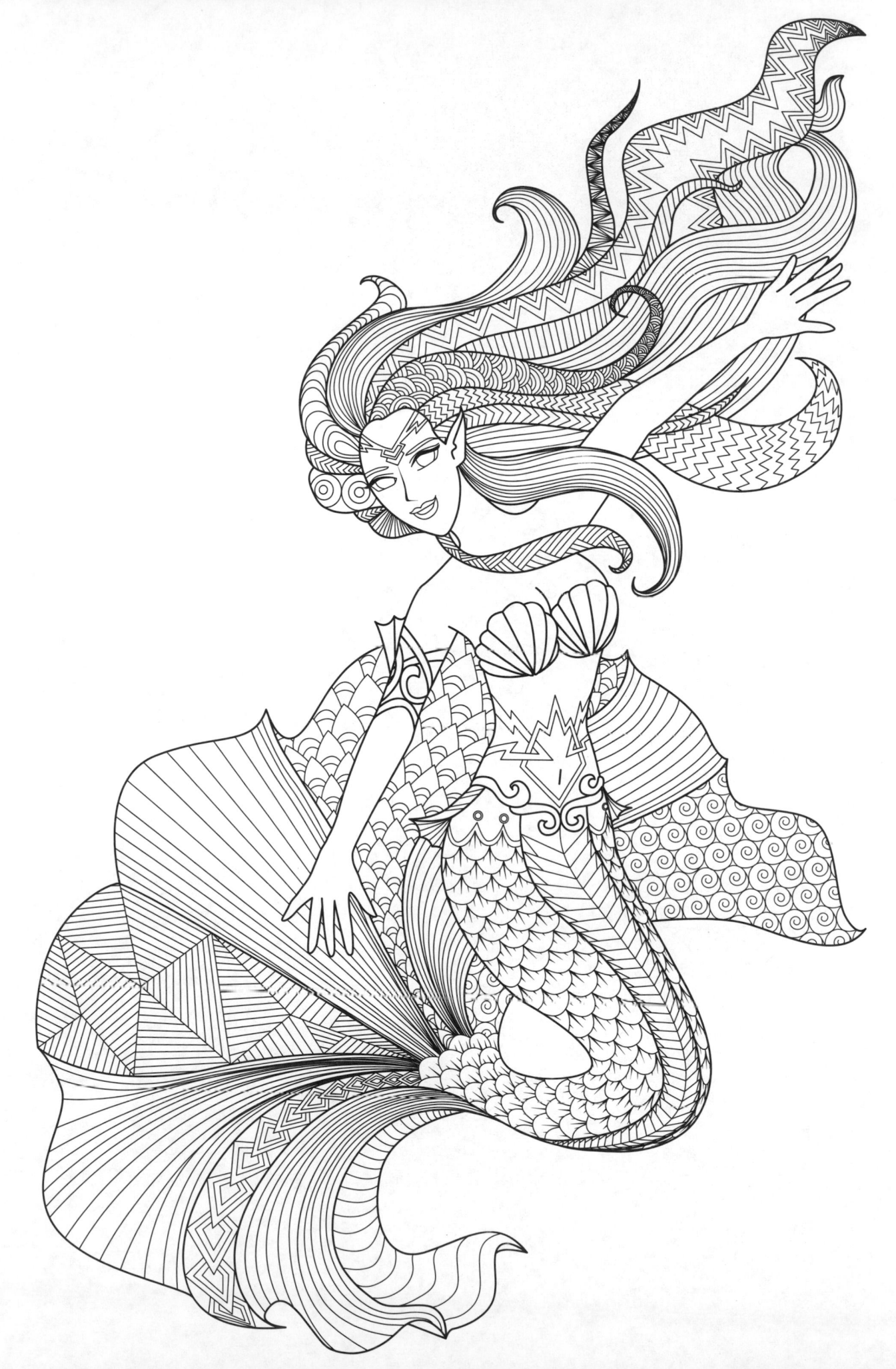

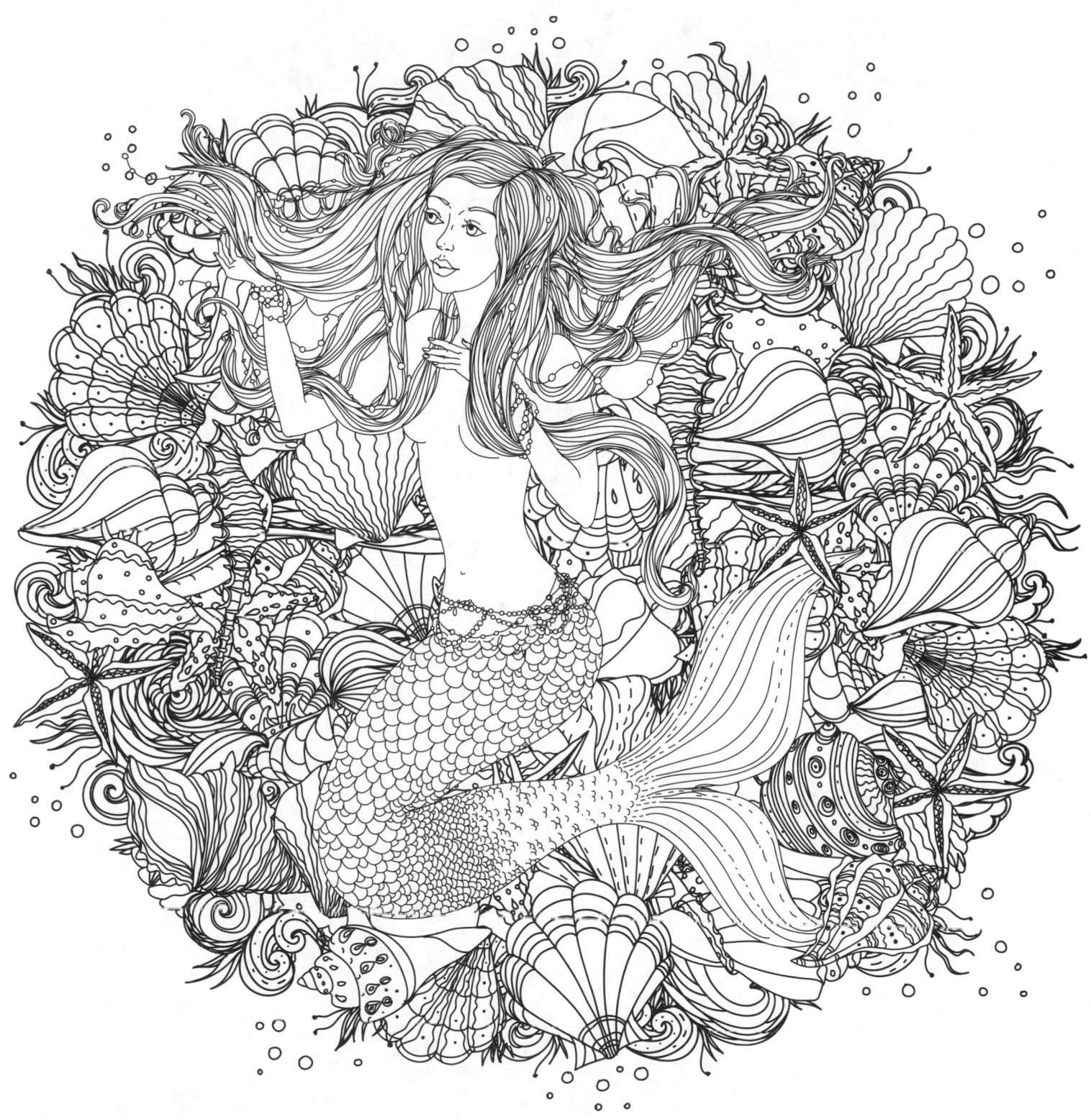

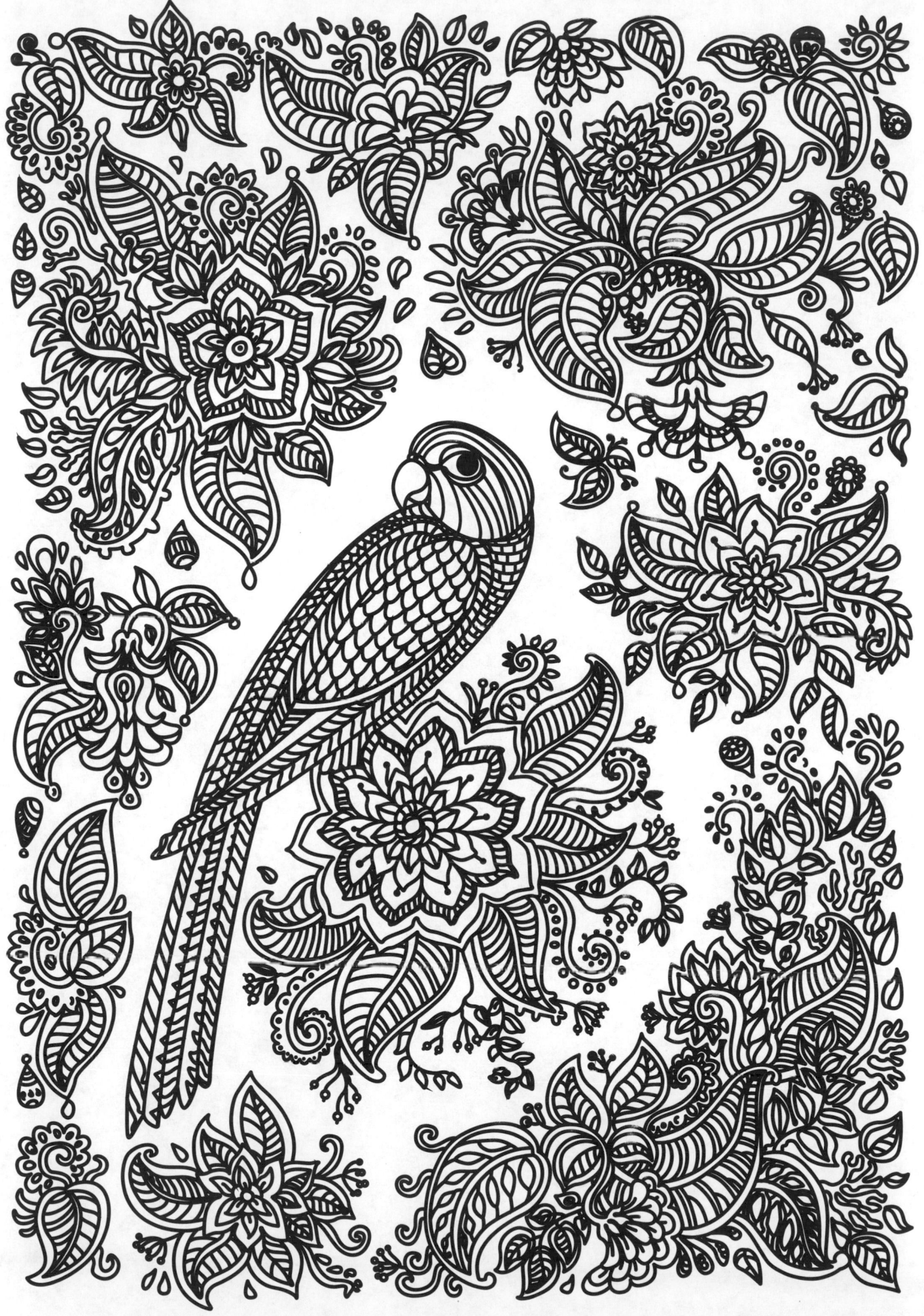

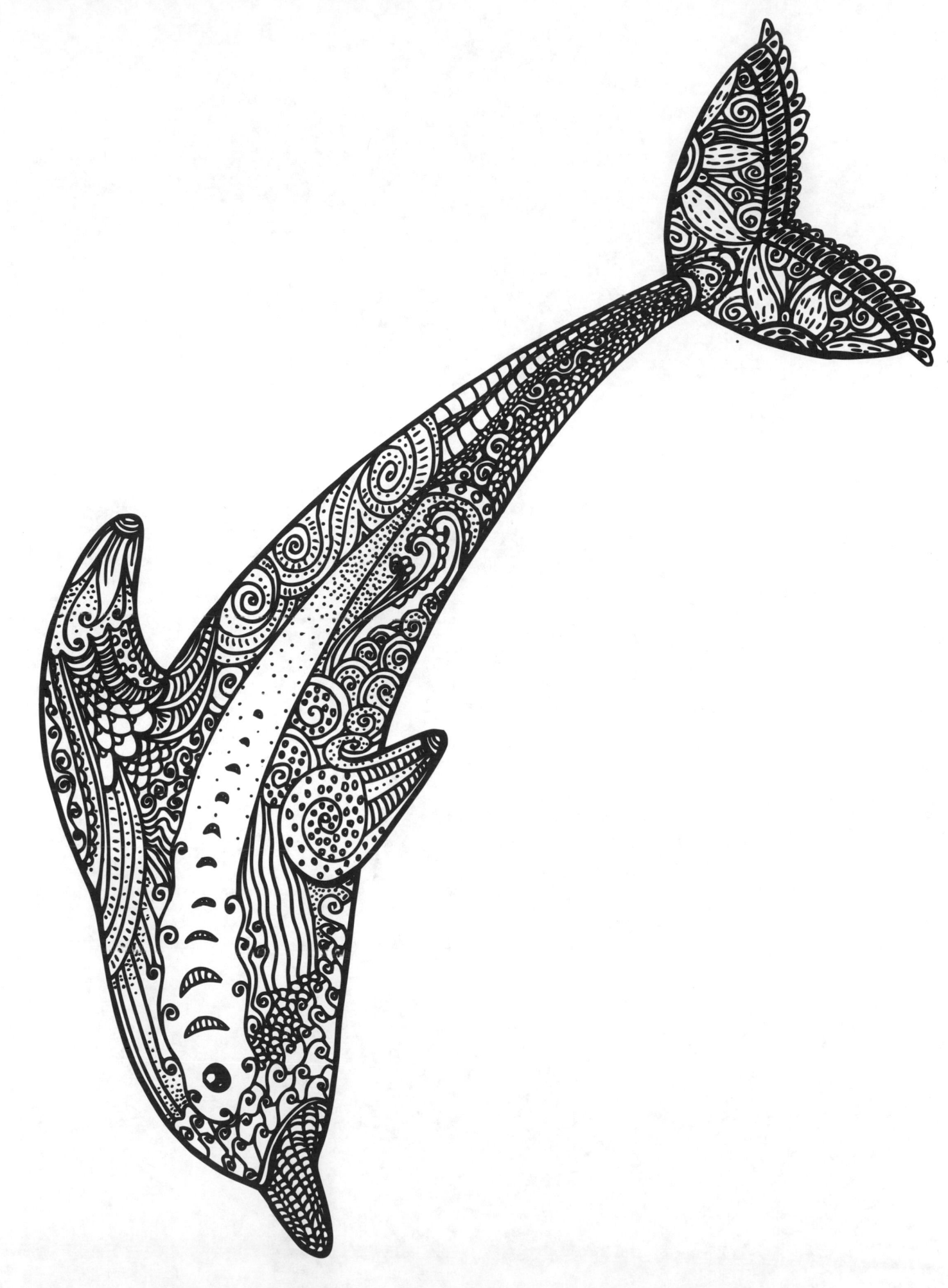

Palette Bars

Use these bars to test your coloring medium and palette. Don't be afraid to try unique color combinations!

Palette Bars

Use these bars to test your coloring medium and palette. Don't be afraid to try unique color combinations!